Caravaggio

Caravaggio

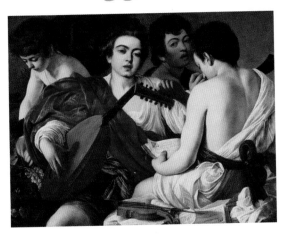

Patrick Hunt

HAUS PUBLISHING · LONDON

First published in Great Britain in 2004 by
Haus Publishing Limited
26 Cadogan Court
Draycott Avenue
London SW3 3BX

A CIP catalogue record for this book
is available from the British Library

ISBN 1-904341-7418 (hb)
ISBN 1-904341-73-X (pb)

Typeset by Lobster Design

Printed and bound by Graphicom in Vicenza, Italy

Front cover: Courtesy the Bridgeman Art Library
Back cover: Courtesy Corbis

Contents

Introduction

Like most great artists, Caravaggio was a man of his age. That age – the final decades of the sixteenth century and early years of the seventeenth – was marked by cultural disjunctures and spiritual uncertainties that are reflected in both his life and his art. After the long sleep of the Middle Ages, the cognitive reawakening of the Renaissance that occasioned Humanism and the Reformation spurred Caravaggio's generation to further the cause of free will and subject all matters of faith to the faculty of reason. This epistemological shift took place during the very years that Caravaggio (1571–1610), alone among early baroque painters, was testing the conventions of art and the behavioural norms of society for himself.

Caravaggio's intellectual peers comprised the post-Copernican generation of scientists and savants for whom empirical observation preceded deductive reasoning as the preferred method of enquiry. Standing out among these enlightened thinkers were Giordano Bruno (1548–1600), Galileo (1564–1642), Giacomo della Porta (1541–1604), and Francis Bacon (1561–1626). Key to their way of thinking was Galileo's assertion that 'in questions of science the authority of a thousand is not worth the humble reasoning of a single individual.' Francis Bacon went further in *The Great Instauration* when he advised 'those who aspire not to guess and divine, but to discover and know; who propose not to devise fabulous worlds of their own, but to examine and dissect the nature of this very world itself, must go to the facts themselves for everything.' Scepticism was the password of the day, a concept that describes Caravaggio's outlook perfectly.

In the arts, Caravaggio was the first European painter to practise the new methodology, but in literature Montaigne (1533–92)

and Cervantes (1547–1616) gave voice to the same cravings for truthfulness to nature. Indeed, what might be considered the theoretical foundation of Caravaggio's unembellished realism appears in the prologue of *Don Quixote* (1604) where Cervantes addresses would-be authors:

in what you are writing, you have only to make use of imitation, and the more perfect the imitation the better your writing will be. And since this book of yours aims at no more than destroying the authority and influence which books of chivalry have in the world and among common people, you have no reason to go begging sentences from philosophers, counsel from Holy Scripture, fables from poets, speeches from orators, or miracles from saints. You have only to see that your sentences come out plain, in expressive, sober and well-ordered language . . . without intricacies and obscurities.

It is pointless, however, to seek connections between Caravaggio and other empiricists and phenomenologists of the day. We know little about his intellectual life apart from the fact that in 1605, at the zenith of his career, his personal library contained but twelve unnamed books. While the libraries, laboratories, and collections of patrons and admirers like Cardinal Del Monte undoubtedly offered inviting places for study, any search for influence or causality yields few rewards when it comes to understanding his genius. If we wish to define Caravaggio's place in the world of early-modern ideas, we would do well to follow Michel Foucault's recommendation and think of such intellectual and cultural relationships as 'discursive formations' common to the age itself. In *The Archaeology of Knowledge*, Foucault speaks at length of such formations, and the 'ensemble' of relations that for him constitute the episteme. 'This episteme,' he writes, 'may be suspected of being something like a world view, a slice of history common to all branches of knowledge, which imposes itself on

each and the same norms and postulates, a general sense of reason, a certain structure of thought that men of a particular period cannot escape.'

If Caravaggio makes an ideal subject for Patrick Hunt's insightful *Life&Times* biography, the *times* in question can be viewed diachronically, taking the response of our own era into account as well as that of the artist. Without question, Caravaggio is the most renowned Old Master of recent times. More articles, books, exhibitions, films and novels have been dedicated to him than to all of his contemporaries combined. Why this is so is not hard to explain. Beyond his penchant for unidealized transcriptions from life, Caravaggio's art addressed a number of issues that are as compelling today as they were in 1600. Among these are the preoccupation with spontaneous violence, the allure of ambivalent sexual identity, the expression of doubt in matters of faith and salvation, and the immersion of the artist in his own imaginative creations.

Patrick Hunt takes a holistic approach to Caravaggio and his work, eschewing the fashion for the kind of over-theorized, ahistorical and deterministic studies that have flooded the market. To be sure, the painter was a poster boy for bad behaviour. There has never been an artist whose biography is more dependent on the police records – and the author does not ignore this fact – but he resists the temptation to interpret Caravaggio's equally volatile paintings by that dark light alone. In recent years, a number of authors have subjected Caravaggio to the rites of psychoanalysis or attempted to 'queer' his paintings for their homo-erotic content. Stepping over such reductive and anachronistic readings like a mountain guide traversing a series of slippery Alpine slopes (an exercise at which the author is also an expert), Patrick Hunt's *Caravaggio* deftly resolves the needs of biography with the exigencies of art. Throughout the book, he makes an effort to conjoin Caravaggio's personal and professional lives, but his conjectures

are never unsupported nor is the meaning of individual paintings made to seem over-determined.

In this one brief text, we have Caravaggio and his times in a nutshell. Never forgetting that the artist was primarily a religious painter, the author's insightful reading of the scriptural and spiritual content of his art is masterful and concise. Hunt's use of contemporary biographies and other primary sources, combined with his grasp of the broader historical context gives weight and balance to his assessment of the artist. Judicious, lucid and elegantly written, this *Caravaggio* – so unlike the artist himself – can safely be trusted.

<div align="right">

JOHN VARRIANO

Idella Plimpton Kendall Professor of Art History
Mount Holyoke College
Massachusetts

</div>

Acknowledgements

I am grateful for the assistance of several persons who have encouraged this manuscript. At Stanford University, I thank the Classics Department – my academic home – and Professor Richard Martin who understands and appreciates my interest in Caravaggio's Classical iconography. At Haus Publishing in London, I thank Dr. Barbara Schwepcke for her vision for the Life&Times series and Editorial Director, Robert Pritchard. I am also thankful for the patient staffs of the Palazzo Bellomo in Siracusa, Sicily, and the Museo Regionale in Messina, Sicily, as well as the Galleria Doria Pamphilj in Rome and the clergy of the Cerasi Cappella at Santa Maria del Popolo, Rome, all of which have let me spend hours with these paintings over the last few years. I greatly appreciate the Warburg Institute in London where I have been allowed to conduct further research on Caravaggio. I would also like to acknowledge eight 'Renaissance' persons without whom this book – whose faults are entirely my own – would never see light: for his scholarship, John Spike, historian extraordinaire whose enviably polished writing is matched by peerless research and whose dates I have generally followed for the painting chronology; for Professor John Varriano of Mount Holyoke College whose personal generosity and magisterial academic sensibility are an inspiration and continual source of insight; for Hilary, my daughter and graduate student of sixteenth century Rome. Generous benefactors Peter and Helen Bing, and last but never least, for my wife Pamela Sommerfeldt Hunt, patient encourager who never loses faith and always believes in me, along with my other daughters Allegra and Beatrice Hunt.

Early Life and Training 1571–1592

Genius, criminal, revolutionary artist, ascetic, bravo, dandy, murderer, rebel, sceptic, sensualist, fugitive, mocker, lay brother. How could all of these epithets be true of one man? In the year 1616, if one were to ask thoughtful and well-educated people to name the most influential geniuses of that age, the answers would certainly include Shakespeare and Cervantes, both of whom died that year. These two geniuses had closed the Elizabethan and Spanish Renaissance Golden Ages and changed literature ever after. It is not unlikely that many prescient persons in Rome would also have added the name of Caravaggio – already dead six years – to such a list. As true recipient of all the above epithets, it is certain now, nearly four centuries later, after a lapse where the later Rembrandt and Velásquez were better remembered, that Caravaggio was the singular artist who blazed into the Baroque Age and transformed the face of art for ever.

Caravaggio was born in the Lombard region around Milan, under the shadow of the Alps. Even the great square towers of the Sforza castles did not cast nearly as long shadows as the mountains themselves. The Milanese were well aware of human insignificance measured against nature's winter storms, boreal floods, fevered plagues and implacable heat in summer. By sixteenth-century standards, Fermo Merisi, the artist's father, was fairly comfortable as a man of some means, owning a little property and with sufficient modest income. He was the castle steward for a member of the famed Sforza family, an aristocratic family, who were still prominent although no longer dukes of this city since 1556. Merisi's lord was Francesco I Sforza, Marchese da Caravaggio, descendant of a previous Sforza Duke of Milan,

Ludovico il Moro and his wife Constanza Colonna, an old Roman Senatorial family of the longest noble bloodline going back to classical Rome.

Most of the details we have about Caravaggio's life come from three fairly contemporary sources, although their biases are often apparent and their details are not always accurate. The first biographer was Giulio Mancini, who published his generally favourable text *Considerazione sulla pittura* between 1617 and 1920; the second was another artist and writer Giovanni Baglione who published his often unkind biography, *Le Vite de' pittori, scultori ed architetti dal pontificato di Gregorio XIII del 1572, fino ai tempi di Papa Urbano VIII nel 1642* around 1649, long after he had feuded with Caravaggio (1603) and sued him for libel; and the third was Giovan Pietro Bellori who vacillated back and forth between scathing criticism and grudging praise. His biography was *Le Vite de' pittori, scultori ed architetti moderni,* published around 1672.

1571	Born in the town of Caravaggio, 25 miles / 43 km east of Milan.
1592–3	Arrives in Rome.
1595	Employed in Rome by Cardinal Del Monte until ?1600
1598	Arrested and placed in Tor di Nona prison [for sword-carrying and brawling].
1606	Murder of Ranuccio Tomassoni.
1606–8	Flight to Naples and Malta.
1608–9	Flight to Sicily and Naples.
1610	Death at Porto Ercolano

After the death of his first wife, Merisi married into a family of good status. Caravaggio's biographer Mancini notes that the painter was born in Caravaggio of 'most honourable citizens, as his father was major-domo and architect of the Marchese of Caravaggio'. Fermo Merisi's bride, and Caravaggio's mother, was Lucia Aratori, as indicated by church records that show their marriage to have been in the countryside of Caravaggio on 14 January 1571. The Marchese was present at the wedding which reflects

the good relationship and esteem held for Fermo Merisi. Another of Caravaggio's early biographers, Baglione, notes that the painter 'was the son of a respectable master builder named Amerigi' and several modern biographers like John Spike suggest that the elder Merisi 'was the end product of several generations of master builders in Caravaggio'. The elder Merisi was seemingly as high in the Sforza hierarchy as one could go without being of noble birth. It is almost certain that only nine months later their son was born in old Milan in the Sforza palazzo near the Duomo on 29 September and thereby named after the patron saint whose holy day it was on the ecclesiastic calendar: St Michael the Archangel. This baby boy was Michelangelo Merisi da Caravaggio whom subsequent centuries now simply refer to as Caravaggio.

It is a notable irony to contrast the peaceful setting of the rustic countryside of the castle around Caravaggio with the later turmoil of the artist Caravaggio's life. Perhaps the aegis of a militant saint – Commander in Chief of angelic hosts – in St Michael the Archangel and his near middle-class status in contrast to the usual servitors and peasants filled the young boy's head with ambition equal to his gift. Knowing his father's position, his relative status

The town Caravaggio is medieval, with turrets circling the town and its small fortress castle, feudal seat of the Marchese da Caravaggio. The fields around town show the old Roman plan of land divided in plots and given to imperial Roman army veterans. Barbicans formed the outlets for its four or five main gates to roads going out in different directions through the plains. Of the original Merisi family, Caravaggio's grandfather, owned a house in the northeast part of the town near the Porta Seriola gate. In the surrounding countryside were several small parish churches such as San Eusebio to the north, San Valeriano to the east, and several convents including Convento di San Bernardino (as well as an oratory to that saint) to the southeast. A large basilica was the Tempio della Beata Virgine to the southeast, built over an old Roman temple to Venus. San Fermo, the name of Caravaggio's father, was the patron saint for the town.

growing up could easily give him the vantage point of being able to see the gulf between the social classes and privileges he possessed weighed against the privileges he could never claim. This knowledge might have also ultimately prepared him for that flexibility of later being able to fraternize with church prelates like Cardinal Del Monte and gentlemen while at the same time he could swagger through the lowlife streets of Rome with thugs and prostitutes. Although the noble Caravaggio and related Colonna families would both later protect, patronize and vie for the subsequent paintings of their servitor's son, that influence alone would not be able to balance or wash away the miasma of violence and crime constantly associated with Caravaggio's name in his last two decades.

Returning to his childhood – where the absence of concrete facts makes piecing his early years and influences together challenging – it is likely that young Michelangelo Merisi moved back and forth between the Sforza household in Milan and the countryside around Caravaggio. The Milan parish where the Merisi family was living in 1572 was that of Santa Maria della Passerella. The plague of 1576 in Milan – which may have killed as many as 16,000 Milanese and another 8,000 in the countryside – probably drove the Merisi family to Caravaggio for some time, by now grown to three sons and a daughter – Giovan Battista born in 1572, Giovan Pietro whose birth date is not known and Caterina born in 1574 – the family was not without the tragedy so common in that day. The plague quickly took Michelangelo Merisi's uncle, grandfather, and then, the worst blow, his father Fermo in 1577 when the future artist was only six years old. Modern Caravaggio biographer John Spike has Fermo Merisi's death recorded as 20 October 1577. Their mother Lucia Aratori Merisi raised the family in the Aratori household in Caravaggio. No doubt the emotional loss must have been bitter to young Michelangelo. It is probable due to his middle-

class social standing that the boy received a basic education where he learned to read and write Italian. As many have maintained, evidence for Michelangelo Merisi's literacy is at least quadruple: 1. An autographed painting, the *Beheading of St John the Baptist* in Valletta, Malta (although this alone certainly does not indicate that he was literate); 2. His near-contemporary biographer Baglione claims in libel litigation from 1603 that Caravaggio wrote verses against him; 3. The artist owned at least a dozen books inventoried in 1605 as 'another chest of twelve books'; 4. Caravaggio's specific autograph contract of 25 June 1605, for Massimo Massimi includes the words *I attest I have written and signed this below in my own handwriting* followed by his signature, although this doesn't make him necessarily literate.[1] It is likely that most of his childhood between the age of six and thirteen was spent in the village of Caravaggio with his own and his extended Aratori family.

Beyond his basic education, his probable lack of close family male role models – since father, uncle and grandfather had been claimed by plague, and his only remaining uncle, Ludovico, was a priest in Milan – may have been a factor that helped develop a deep bitterness in him. This may have assisted in fostering a behavioural proclivity to what is anachronistically identified as juvenile delinquency, especially if his mother Lucia had her hands full with raising her family, although this is entirely speculative. The other cultural influence of Lombardy itself may have also been a factor in his childhood. Certainly the path charted by the town's previous most famous Renaissance son, Polidoro da Caravaggio, the classical landscapist who departed for Rome in 1515 but left it during the Sack of Rome in 1527 was perhaps a bad omen for his later namesake: he died in unfortunate circumstances, probably murdered in 1543 in Messina, Sicily. Polidoro was a justly celebrated Lombard painter whose life may have influenced the young Merisi in more ways than one.

Although there seems to have been no documented family tradition in the arts, young Michelangelo Merisi (hereafter called Caravaggio) must have had considerable recognizable talent and desire as a boy to become an artist. There was an architect-builder in the family who lived in Rome named Giulio Merisi da Caravaggio. Giulio built Palazzo Spada for Cardinal Capodiferro around 1549 in the Piazza di Quercia, but the connection is still tenuous even given Fermo Merisi's occupation as builder or ducal contractor. Caravaggio entered into an apprenticeship at the age of thirteen, and lasted the standard four years (circa 1584–88). Bellori's tale about the young Caravaggio helping prepare glue for painters is undocumented to date: 'he happened to prepare some glue for some painters of frescoes and, driven by the desire to use colours, he remained with them, applying himself totally to painting.' His later ability to paint nature so faithfully suggests that he learned much by observation from nature. He could observe much around Caravaggio while growing up in Lombardy's rural settings of fields, hills and forests with the Alps on the horizon, although landscapes were never his métier as a painter.

The first master under whom he apprenticed was the Lombard painter Simone Peterzano (circa 1540–96) – having been a student of Titian, Peterzano was clearly proud of his pedigree, given that he signed on his frescoes *Titiani alumnus* – then probably in his mid-forties and at the height of his career. Peterzano was a Mannerist painter of devotional-style frescoes and altarpieces. He worked for the Borromeo see and archbishopric during the flurry of Post-Tridentine religious reaffirmation of Catholicism in the Counter-Reformation. Archbishop Carlo Borromeo was a strong advocate of this resurgent and even repressive movement in Milan. Carlo Borromeo was also admired by fellow clerics and even much praised for 'heroism' for selling his household gold and silver plate to feed starving parishioners and having clothes made

for the dispossessed from his household tapestries, unlike many of his fellow churchmen in the face of the plague in Milan between 1576 and 1578. Carlo Borromeo's reward for charity was partially shown by early canonization in the Church in 1610 by Pope Paul V Borghese. A typically representative painting of Peterzano from 1573–8 and painted under Carlo Borromeo's patronage is his *Entombment*, critics have noted Caravaggio's debt to this painting of the same subject in his own *Entombment of Christ* (1602–03). Apprentices would have been expected to grind colours from natural sources for painting pig-

Padre Negrone: 'In the Archbishop's palace, one did not see carriages, horses, lavish tapestries and carpets, canopies and curtained beds; rather bare and unfurnished rooms, empty walls and bedsteads . . . This was because Archbishop Carlo draped the poor in the palace textiles to keep them warm during the winter . . . As people walked outside, those inside screamed, beating against the windows, lamenting their calamities . . . Carlo consoled those sick people with great humanity as far as he was able . . .'

ments, and the young Caravaggio must have spent hours preparing canvases and laboriously working at grinding and mixing powdered materials as required by his terms of training in the home of Peterzano in Milan's San Giorgio al Pozzo Bianco parish district. It is likely that young Caravaggio learned the standard Catholic iconography in Peterzano's training, in addition to his artistic apprenticeship. The visual literacy emphasizing Counter-Reformation conventions on newly ultra-conservative mores and increasingly rigid theology seem to be a starting-point for Caravaggio's intellectual resistance to liturgical hagiography, ultimately crystallised into this opposite direction. Lombard painting before Caravaggio was already famous for depicting background – something definitely omitted in Caravaggio's mostly *chiaroscuro* paintings.

Significantly, while depictions of Lombardy landscapes are not any more unusual in the late Renaissance than those other Italian

regions, the local style of 'direct observation of nature' was established by such artists as Vincenzo Foppa of Brescia, Girolamo da Romano (also known as Romanino) and above all Lorenzo Lotto in Bergamo in the mid-sixteenth century. How deep this assimilation of local detail and tradition was for the young Caravaggio is directly related to his training, mostly because he was already in his early twenties when he finally left Milan for Rome. After his apprenticeship, he returned to Caravaggio between 1588 and 1592 until the age of 21. Since he spent at least half his life in Lombardy, this northern setting must have been important to his development. The climate under the Alpine shadow was cooler than in the south where he lived the second half of his life, and the shadows of Lombardy's hill and mountain country extended far over the landscape. But this period of his adolescence and early adulthood is a lacuna that both his contemporary and modern biographers have been understandably loath to fill with conjecture. It is also likely that the Spanish overlords in Milan after the Habsburgs came to power (since Philip II had inherited the old Sforza duchy in 1556) were not well liked by the local Lombardese, and young Caravaggio would have been no exception.

No doubt his family association with the Sforza-Colonnas would have provided ample political grievances and probably vocalized preferences for the old Sforza rule that may have reached Spanish ears. In any case, two of his contemporary biographers – Mancini and Bellori – suggested that his departure from Milan in 1592 was darkened by some problem, possibly having spent a year in prison for unspecified criminal offences, but these claims are as yet undocumented, although Spike agrees that Caravaggio was 'unable to toe the line, before he was twenty he had already spent a year a prison'.[2] Bellori states that young Michelangelo Merisi da Caravaggio 'fled Milan on account of certain quarrels' and Mancini said 'he studied diligently for four or six years in

Milan, although from time to time he would do some crazy thing caused by his hot-tempered nature and high spirits.'[3] Baglione would certainly have personally tasted Caravaggio's 'quarrelsome' nature, culminating in his [Baglione's] libel suit brought in Rome against the artist in 1603 for 'scurrilous verses' purportedly written by the artist. Bellori also states that Caravaggio must have painted portraits in the interim between his apprenticeship in Milan and returning to the town of Caravaggio or on visits back and forth between the two: 'for the next four or five years he went on making portraits' and Bellori makes a point not supplied elsewhere that in this interim Caravaggio travelled to Venice to study the works of Giorgione: 'he went to Venice where he came to enjoy Giorgione's colouring so much that he chose him as a guide to imitate.' The Venetian interlude is debatable; what is not is his Lombardy background, as Milan was filled with local paintings like those pietistic canvases and frescoes of the earlier Giovanni Gerolamo Savoldo (fl. 1530s) and the contemporary Antonio and Vincenzo Campi (fl. 1570s–1580s), all of whom used light in dramatic ways that would directly influence Caravaggio – in such paintings as Savoldo's *St Matthew and the Angel* which, as Puglisi notes, had Giorgio Vasari's praise in 'pictures of night and fire' and were themselves possibly inspired by Leonardo da Vinci's time spent in Milan painting for the Ambrosian church, among other patrons.[4] It is most probable that Caravaggio spent considerable time and energy observing and experimenting with local Lombard traditions and styles he could absorb in Milan while at the same time intellectually distancing himself from the liturgical style.

His mother Lucia Aratori Merisi died on 29 November 1590 and the artist fairly quickly liquidated his patrimony – most likely inherited plots of land shared by his brother Giovan Battista, who became a priest, and his sister Caterina, his surviving sibling family in Caravaggio – and used the considerable sum

of 1,100 imperial lire for purposes unknown. Historians state that Caravaggio received 350 imperial lire in 1588 after selling a plot of land and his share of the final settlement in 1592 was for 393 imperial lire. If the 1,100 lire from the final estate liquidation were divided roughly in thirds, Caravaggio could have received around 393 lire. The odd fact is that this money should have sufficed to pay for his journey and to settle him fairly comfortably in Rome for a year or so until he could generate new income by painting. But instead he would arrive in Rome poverty-stricken and able to afford only the lowest circumstances.

The many speculations on what he did with the income, including paying off legal penalties or fines, settling debts or litigation, or profligacy with courtesans and rakes, are all somewhat consonant with his later lifestyle but equally difficult to substantiate at this point. Many, like Seward, have discussed Mancini's near illegible marginal note where he claims that young Caravaggio was somehow part of a Milan fight in which an 'aristocrat and a prostitute' were involved and where a Milanese *sbirro* (Spanish) policeman was killed. It is likely that Caravaggio learned some form of swordplay in Milan as it was customary for a young man of the city to carry a weapon either for self-defence or to affect the posture of a *bravo,* simulating the retinue of a nobleman's guard or just being macho like many other young men of his day in a city known for this behaviour. According to Mancini – unlike Bellori and others generally favourable to Caravaggio – this purported brawl (Caravaggio's first scrape with the law?) resulted in Caravaggio's spending a year in prison and financial loss of part of his patrimony,[5] although this remains unproven. His last liquidation of his inheritance in Milan and Caravaggio appears to have been concluded in May 1592, and he arrived in Rome no later than the spring of 1593 aged 21 or 22.

Poverty and Patronage in Rome, 1592–1595

Baroque Rome was the ultimate city where an artist could flourish with the right connections. The infamous and disastrous Sack of Rome in 1527 by imperial troops of Charles V was a low-point for the *Urbs aeterna* when almost a quarter of the then 60,000 people perished and at least 12 million gold ducats were lost from various treasuries, not to count the horrific looting of church relics and art and the destruction of over 30,000 houses. But by the end of the sixteenth century, Rome was rising from the ashes and its population had doubled since before 1527. The monumental ambitions of the Church to rebuild Rome's reputation and restore her former glories as experienced under the pagan emperors but now as the capital of Christendom required enormous resources and massive planning of a propagandistic nature. Christ on earth may not have had a place to lay his head, but the proud Church would certainly stop at nothing to compensate for this apparent oversight of humility. For those who had any skill at all in a decorative craft, Rome was the ideal destination: its embellishment could seemingly provide employment for more artisans than the rest of Europe.

It is commonly estimated that more than 34 grand projects in churches and at least as many palaces went up in the frenzied rebuilding of Rome in the half century between 1550 and 1600. The Borghese family alone could account for refitting or building many churches and Sixtus V (Felice Peretti, 1585–90) was one of the most tireless proponents of *Roma Resurgens* after being recalled from Venice for being too ruthless as Inquisitor General. The final completion of the Dome of St Peter's had only just been completed in May 1590, with its crowning cross erected only two or

three years before Caravaggio arrived. *La Pianta di Roma al Tiempo di Sisto V (1585–1590)* demonstrates many new Sistine projects. Christopher Hibbert's *Rome: Biography of a City* suggests that the ambition and even equally ruthless town planning of Sixtus left an indelible mark on Rome – with the help of his master architect Giacomo della Porta – 'more than any other pope of the Counter-Reformation'. Some of his vast projects included restoring the old Roman Severan aqueduct of the third century AD, renaming it after himself as the Acqua Felice. He added new bridges over the Tiber (including the Ponte Sisto connecting to Trastevere), rerouted and widened streets for panoramic vistas ending in relocated obelisks and extended the city outwards to the north and east. Under his compulsive building, portions of the Vatican itself, the Lateran and Quirinal palaces, Pius V's library, the Sistine Loggia at St John Lateran, the less famous Capella Sistina at Santa Maria Maggiore and many other projects were either begun or extended. Clement VIII was also tireless just before the 1600 Jubilee in restoring early churches like Santa Cecilia and Santa Susanna in preparation for a million pilgrims visiting Rome. It is likely that as many as 400–500 artists were working in Rome between 1600 and 1640.[7]

The volume of empty new wall space in Rome cried out for religious paintings that disseminated the stringent theological assertions of the Counter-Reformation against the Protestant insurgents of the previous century. One of Sixtus' court painters was Federico Zuccaro (c. 1542–1609) who founded the painter's guild in Rome, the Academy of St Luke, in 1593 about the time Caravaggio arrived there. Rome was the only place for a young artist in his early twenties with dreams and equal energy. There are hints that Caravaggio lied about his age, trimming a few years off to cast himself in a more favourable light relative to successful artists his own age already with their own studios in Rome.

As an unacquisitive man when it came to personal belongings,

Caravaggio may have arrived only with his artist's austere necessities and a few chests of clothes and other belongings. What he might have thought arriving in Rome the first time in the spring is unknowable. Even to someone from a famous city like Milan, it must have still been overwhelming relative to the cooler north. Not only the typical cacophony of a great city but also the sounds of construction everywhere must have assailed his ears. As Puglisi notes, if Rome in 1600 had a population of over 120,000, at least 10 per cent of this was ecclesiastic. Furthermore, there was a glut of men (no doubt a great number of artisans and many more recently discharged army veterans out of work) and a dearth of women – except for prostitutes, whose market was due to the overwhelming numbers of men. Additionally, 1600 was a Jubilee year and at least half a million pilgrims were expected to fill the city within the decade Caravaggio himself arrived.[8] The combination of testosterone and religious fervour from all these city-dwellers in the hot climate of Rome must have been a heady but dangerous mix for someone as hot-blooded as Caravaggio was said to be.

The next three years of Caravaggio's life are not much easier to reconstruct. In Rome his poverty seems to make him relatively invisible because there are very few, if any, fixed addresses with which to associate him. Bellori stresses Caravaggio's poverty: 'Having moved on to Rome [from Milan], he did not earn enough to pay his expenses in advance, so he lived there without food and lodgings and unable to afford to pay the models without which he did not know how to paint.' But like many young men his age, he must have been both resourceful and fairly tolerant of his circumstances. How he survived is somewhat speculative, but whatever of his inheritance remained does not appear to have lasted long in Rome. It seems very likely that his priest uncle Ludovico must have helped with introductions to churchmen and church contractors for possible patronage. Caravaggio would also have

been likely to take commissions for small projects from wealthy private citizens who were among the growing merchant and middle class that serviced the Church's projects. Baglione stated that Caravaggio 'settled down first with a Sicilian painter who had a shop of crude works of art'. Although Baglione's chronology is confused, this Sicilian would have been Lorenzo, as noted shortly.

A new pope, Clement VIII, Ippolito Aldobrandini, had just acceded to the Papal see in 1592 and his building projects were hardly less monumental in scale than those of his predecessor. But Clement did not exactly live up to his name for 'clemency' – church heresy, venality and sensational crime were not to be tolerated. The prostitutes were an affront to the Church, plying their trade in church piazzas and in front of prelates' palazzi, and the new pope tried to corral them into just a few poor quarters of the city after being unsuccessful in removing them altogether. The public and private outcry when Clement tried to outlaw prostitution or banish its practitioners must have reached the very ears of the ascetic pope himself and persuaded him it was entirely impractical: if he needed workmen, they needed women or he would have an outright war of Lysistratan proportions. Violence in Rome – in which Caravaggio played a visible part – was endemic: as John Varriano notes, there were 658 executions carried out in the city during Caravaggio's time there, most of which occurred under Clement VIII's thirteen-year papacy from 1592–1605.[9] Caravaggio could not have been blind to these often-public spectacles and may have even been part of the clamorous fascinated crowds attending or following the condemned to the gallows or the stake.

Clement's other papal severities were soon visible. The dubious murder charge against the young aristocrat Beatrice Cenci was a 'crime' committed against her incredibly brutal stepfather Francesco by her lover at the instigation of her and her family. This was done as much to end an abusive relationship and her

imprisonment in the Aquileian castle of La Petrella as anything else. Beatrice's public beheading in 1599 was a huge draw to the teeming Roman population. She bore her death nobly when all her appeals to the pope were ignored. But the whole Cenci family was duly punished and dispossessed under Clement's fierce rule and his harsh repression of any critics. While the Church seemingly schemed to possess the huge Cenci inheritance that would be gained for Clement's papal treasury, the pope was also taking a hard line on Roman law in an otherwise ungovernable city. Famous 'heretics' like the mathematician and philosopher Giordano Bruno were burned at the stake in spectacular *autos-da-fé* in 1600 in the Campo dei Fiori as a warning to the less faithful. Bruno had become a Calvinist around 1578 and publicly advocated Copernican cosmology at Oxford in his flight from the Catholic Church, and lectured on non-geocentricity. Bruno also wrote copiously on the connections between magic and science and, hoping religious reform was in the air, went to Venice where he was arrested by the Inquisition in 1592 and extradited to Rome. In terms of Post-Tridentine dogmatic severity it is ironic that Bruno's 'heresy' was probably far less egregious than what Caravaggio soon committed to canvas.

CARAVAGGIO AS INNOVATOR:
– No epic scenes with scores of people or masses
– Highlights the individual
– Drama is as much from the character as the event
– Humanity is more important than divinity
– Saints are the same as sinners
– *Chiaroscuro* instead of detailed background
– Inventor of still life: fruits, flowers and glass he was unparalleled until Vermeer
– Nature was his only teacher
– Art imitates Life (in this case Caravaggio's life)

Caravaggio's first known clerical patron – Monsignor Pandolfo Pucci – in Rome was probably introduced by his uncle. Pucci was related by marriage to the Colonna family through Constanza

Colonna, Marchesa of Caravaggio, and he was steward to Camilla Peretti, sister of the recently deceased Sixtus V. Caravaggio lived for a few months in 1593 in the Roman house of this priest and painted pietistic or devotional art, unpleasant hackwork that was necessary because of his poverty. Pucci became known by Caravaggio's infamous epithet as *Monsignor Insalata* because the frugal priest fed Caravaggio so poorly. As Mancini related between 1617 and 1621: 'he went to Rome, where being poor, he stayed with Pandolfo Pucci de Recanati, a beneficiary of St Peter's, where he had to work for his keep and perform services which did not befit him; what was worse, in the evening he was given a salad which served as an appetizer, main course and dessert . . . Having departed greatly dissatisfied after a few months, from then on he called this master benefactor of his *Monsignor Insalata*.' Mancini is also the primary source for the chronology of several paintings Caravaggio completed at this time for Pucci and his family at Recanati in the Marches of Umbria: 'During this period he made him [Pucci] some copies of devotional images that are in Recanati, and, for sale, a boy crying because he has been bitten by a lizard which he is holding in his hand, and afterwards another boy peeling a pear with a knife, and the portrait of an innkeeper at whose house he used to board . . .', among others, all between late 1592 and early 1593. The suggestion that some paintings went to Pucci and others were still for sale is important evidence that Caravaggio was already looking beyond this first patron whose tastes he was unlikely to have shared. Caravaggio's next recorded position, possibly also in 1593, seems to have been as a stock painter in the Roman studio of Lorenzo, an obscure mass-production artist from Sicily (as Baglione noted) for whom Caravaggio painted heads with alacrity and was probably paid 'by the head'. Soon thereafter he worked in the studio of Antiveduto Grammatica (1571–1626) known for portraiture of Roman notables.

But Caravaggio must have had his eyes open for better employment because he was shortly thereafter working in the best studio of Rome, that of Giuseppe Cesari (1568–1640) and his brother Bernardino Cesari (1571–1622). Giuseppe Cesari was also soon the favourite painter of the new Pope Clement VIII and was sufficiently well regarded and placed in high circles to be knighted as Cavaliere d'Arpino later in 1600. Baglione comments that, after living with the Sicilian painter, 'Then he went to stay for several months in the house of Cavaliere Giuseppe d'Arpino.' Bellori confirms some of this, stating immediately after his disparaging comment that Caravaggio did not know how to paint without the models he couldn't afford, 'Michele was forced to enter the services of Cavaliere Giuseppe d'Arpino, by whom he was employed to paint flowers so realistically that they began to attain the higher beauty that we love so much today . . . But he worked reluctantly at these things, deeply regretting that they kept him away from figure painting.' While there are some indications that he was treated like a far lesser artist, such as suggestions he slept on a straw mat, possibly even in the studio, Caravaggio worked in the Cesari brothers' studio eight months, although it might have rankled him somewhat because the two successful brothers were his own age and already becoming quite famous and wealthy. On the other hand, Caravaggio seems to have respected Giuseppe Cesari greatly for his painterly technique in a style that was more Raphaelesque than Mannerist in derivation, as can be seen in Cesari's fresco *Battle between the Horatii and the Curatii* in the Palazzo dei Conservatori, Rome. How Caravaggio came to the attention of the Cesari brothers is unknown, but he must have been fully aware of their success to have himself employed there; vice versa, the brothers must have noted Caravaggio's gift through either piecemeal painting or possibly through one known painting most representative of Caravaggio's earliest corpus in Rome, *Boy Peeling Fruit* (c. 1592–3), that Mancini mentioned, or maybe

others unknown because they have not survived. Thus Bellori is wrong to claim that Caravaggio painted only flowers and fruit for the Cesari workshop.

Boy Peeling Fruit 1592-3 is a genre half-length piece (64 × 51 cm) combining a relatively uncommon type of new painting subject – that of still life – with Leonardesque colour and light. It could be called peaceful and reflective judging by the lack of strong emotion on the boy's face, but this is in opposition to the dramatic lighting. The extremely dark background contrasted with the white shirt of the boy prefigures his later hallmark *chiaroscuro*. The painting doesn't have to mean anything beyond its artist's mastery and is already sufficiently recognizable as a Caravaggio to suggest the artist could buck trends and appetites because he knew what he wanted to do very early in his profession.

In the employ of Giuseppe Cesari, Caravaggio seems to have developed even greater skill in rendering nature through still life (*natura morta*), judging from his surviving paintings in this genre. Although it is more visible later, his mastery of still life can be seen in the *Basket of Fruit* (between 1595 and 1596) now in the Pinacoteca Ambrosiana collection, part of which derived from the possessions of Cardinal Federico Borromeo (1564–1631) later Archbishop of Milan. Nephew of Carlo Borromeo, Archbishop of Milan during Caravaggio's youth, Federico was a Milanese not only related to the Marchese Caravaggio but also first Cardinal Protector of the Academy of St Luke, the painters' guild whose lectures Caravaggio might have attended as early as 1593 if he is the 'Michele da Milano' recorded in the meetings. Whether or not it is from his time with the Cesari brothers, which is dubious, its wormy fruit and withering leaves make an interesting pun on *natura morta*. Cardinal Borromeo himself later praised the painting as unique in his collection.[10]

Probably painted during or very near his period in the workshop of Giuseppe Cesari or even among the works that secured his

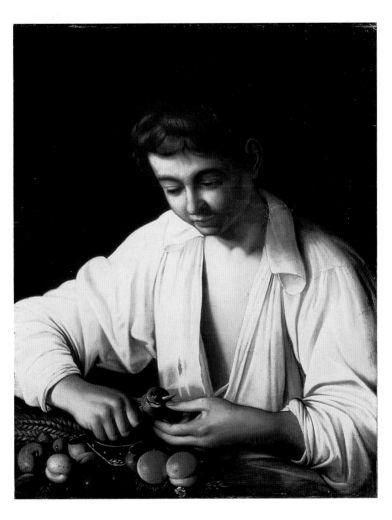

Boy Peeling Fruit

position with the brothers, three paintings of note may say something about Caravaggio's life at this time beyond his artistry. *Boy with a Basket of Fruit* (c. 1593), the probable self-portrait known as *Sick Bacchus (Bacchino malato)* (c. 1593), and *Youth Bitten by a Green Lizard* (c. 1594–95). These paintings were even more highly prized in 1607, when the Borghese family forcefully took both of the first two paintings from d'Arpino's studio. In *Boy with a Basket of Fruit* (70 × 63 cm), the boy is confrontational in gazing out at the viewer and yet softer and less crisp than the fruit. The boy may be a portrait of another young painter friend from Sicily, Mario Minniti, at least six years his junior. There is something puzzling in the amount of attention Caravaggio paid to the fruit whose hard edges contrast with the fuzzier lines of the boy. The highlights on the boy are also more obliquely left where the fruit highlights are more frontal. There may be in fact two time settings and dual sittings here. As a possible allegory, the grape leaf ages and withers and so will the boy.

In *Sick Bacchus (Bacchino malato,* 66 × 52 cm), a title supplied by Roberto Longhi in recent times, we have another even more curious but equally confrontational paradox. Bacchus is usually the image of health and a composite of fertility-virility unless overtaken by his own wine excess. It is extremely unlikely for Caravaggio to have complex Dionysian imagery before he met Cardinal Del Monte. While this presupposes exposure and knowledge Caravaggio is unlikely to possess, one primary difference is that the Roman types usually show a staggering, slumped or near-sleeping Bacchus. Not so here. This Bacchus is wide awake, gazing at the viewer. That it is Bacchus is clear from the iconography of ivy leaves in his hair and the yellow-green grape cluster in his hand and the purple one on the table. Baglione said of this time, making it chronologically later than the Cesari studio: 'After this he tried living by himself, and he made some small pictures of himself drawn from the mirror. The first was a Bacchus

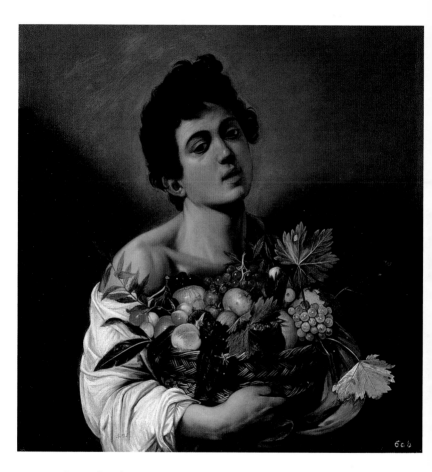

Boy with a Basket of Fruit

with some bunches of various kinds of grapes, painted with great care but a little dry in style.' Modern critics' comments of 'austere' or even 'jaundiced' seem more apropos than merely 'dry'. The peaches in the painting are not necessarily Bacchic, but some find them an echo of sexual imagery and 'bawdy or buttocks' and even homosexual insinuation. So why does this Bacchus – said to be a self-portrait of Caravaggio – look so unhealthy?

Longhi's title and suggestion of sicknesss in *Bacchino malato* appear to come in part from the whitened lips and discoloured facial hue. The greenish pallor of the skin and the parched lips add to the near-querulous 'anxious' look and contorted facial angle and body tension. Moreover, the figure of Bacchus-Caravaggio is in direct contrast to the fruit. As the source of liquid drink, Bacchus of all gods, as Euripides sang, the god of joy, should be ruddy from health and wine, not ghastly and pinched unless from excess. On the other hand, an excess of wine can be both diuretic and dehydrating. Was Caravaggio allegorizing his own experience – what mortals suffer because they are not gods, however one thinks oneself to be immortal in youth – by painting himself in the picture? The picture is now thought less likely to be connected to Caravaggio's recorded illness, as Roberto Longhi surmised.

The third picture from this period, *Youth Bitten by a Green Lizard* (65.5 × 50 cm), now in Florence, was widely copied within several decades, some seemingly by Caravaggio himself, with at least one in London from around 1600. The immediacy of the painting is striking, as is the pain and tension in the boy. Caravaggio has highlighted the two areas most demonstrative of the boy's abrupt recoiling, his right hand being bitten and his shocked face. The lizard itself can be a symbol of lust. Some art historians see the painting as a 'wicked satire' or a satire on the sense of touch or a painful commentary 'on the disappointment of amorous love'. Others maintain Caravaggio is merely reflecting a

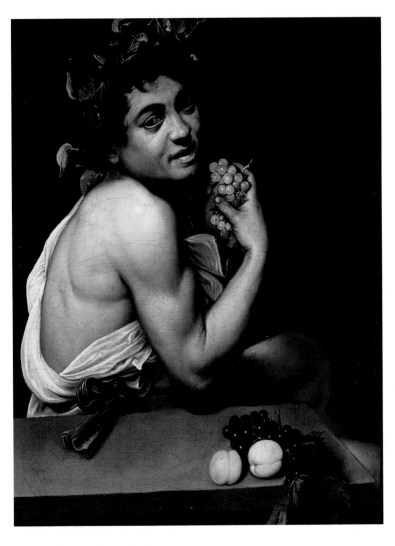

Sick Bacchus (Bacchino malato)

transitory instantaneous moment here or, more complex, teasing with a sophisticated homily with a triple pun on the dangers of youthful sensuality and eroticism and how bitter (*amaro*) love (*amore*) can become if eroticism – like this lizard (*ramarro*) – is the only experience.[11] These three paintings taken chronologically are increasingly characteristic of Caravaggio's sense of drama and growing mastery in depiction of trouble or pain.

Either before or while working in the Cesari workshop, it is thought that Caravaggio was seriously ill for some months. Mancini is the near-contemporary source for this, saying, 'In the meantime he was struck by an illness and, being without money, he had to go to the Ospedale della Consolazione. During his recovery he made many paintings for the prior of the hospital who brought them to Seville (or Sicily?), his home.' But Mancini places Caravaggio's illness before his time in the Cesari household and studio. The stay in the Ospedale della Consolazione was either in 1593 or around 1595–6 and was possibly due to being severely kicked by a horse. This mendicant religious hospital was a charity hospice for those without resources, and it is possible that the same Sicilian artist Lorenzo may have been the one who brought Caravaggio there and for whom Caravaggio had been painting. Lorenzo seems to be the artist who also employed the young Sicilian artist Mario Minniti, a fellow countryman several years younger than Caravaggio who later provided life saving help to him in Sicily. Spike supposes the break with the Cesari brothers came because of an illegal activity that led to their abandonment of Caravaggio not at a doctor in Rome but at the scene from which they fled, leaving him to the compassion of Lorenzo and the Ospedale for destitute persons.

In *Bacchino malato* was Caravaggio suggesting he knew something about his own potentially disorderly behaviour? Given his later preference for the wild Ortacchio district in Rome between the Portogallo Arch and the Piazza del Popolo and its hordes of

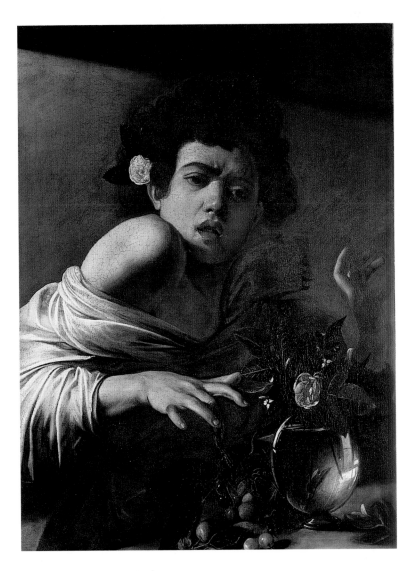

Youth Bitten by a Green Lizard

prostitutes, drunken orgies and swordfights, all of which he would know too well, the artist may have already applied a blistering self-diagnosis to his early delinquency. Such honesty and lack of self-flattery would not be beyond him at any point in his artistic career. The break with the Cesaris may have been either for his own self-protection or possibly because his behaviour was impinging on their social standing.

"The Lizard Killer in Corinthian Bronze: O treacherous boy, spare the lizard, creeping toward you, it wants to die in your fingers.' The matches between Caravaggio's painting and this odd little poem are not only that they involve both a boy and a lizard, but also that the two are connected by fingers (surely a rare factor), that the poem is about a work of art, and finally that it is from classical antiquity . . . It hardly seems possible that there is not a direct association.'
(Gilbert, 1995, 252)

Not returning to the Cesari studio, Caravaggio then moved in 1593 into the household of Monsignor Fantin Petrignani, according to Mancini, 'who gave him the use of a room'. Bellori made Caravaggio's move a bleaker choice: 'he took up the offer of Prospero [Orsi], a painter of grotesques, and left the house of Giuseppe to compete with him for the glory of painting.' Whatever the cause of the change in venue after his convalescence, if the revised chronology works, the move from the Ospedale to another Monsignor may possibly be due to Monsignor Petrignani's yet unknown but not unlikely connection to the Ospedale. Caravaggio's stay with Petrignani, a veteran churchman who had served in various capacities in Lazio and Umbria, must have been equally short to receive so little mention in only a brief phrase or two by Mancini. 'Use of a room' could be either for living arrangements or for a studio or both.

The repertory of paintings Caravaggio made grows steadily into 1594–95 even if his circumstances were uncertain. Baglione then suggests Caravaggio's opportunities were limited as he couldn't sell his art and needed rescuing: 'He was unable to sell these

works [*Bacchino malato* and *Youth Bitten by a Green Lizard*] and soon found himself in a pitiable state without money, and very poorly dressed. Fortunately some charitable gentlemen of the profession came to his aid, until Maestro Valentino, an art dealer near San Luigi dei Francesi arranged to sell a few of his paintings.' There is a suggestion that *Youth Bitten by a Green Lizard* first sold for a pittance of around 25 giuli. It is unknown who these 'charitable gentlemen' were or if they were even of the 'profession' of painters. If they were, they may have been fellow artists from the Academy of St Luke or even someone connected to Cardinal Borromeo as *ex officio* prelate over the Academy. One artist friend seems to have been Prospero Orsi who helped Caravaggio secure a venue to promote and sell paintings via Maestro Valentino; here he would come into contact with his primary future patron, Cardinal Del Monte, who lived close to San Luigi dei Francesi. Nearly all biographers assert that he continued painting subjects like the *The Card Sharps* (*I Bari*) and the *Gypsy Fortune-Teller* in 1594–95. It is worth noting that most if not all of these early paintings were not commissioned paintings but subjects of Caravaggio's own choice. If such a chronology is inaccurate, it lessens Caravaggio's originality by suggesting he painted only what was asked of him. At some point, Caravaggio's break from tradition and establishment of an innovative style must have been the quality that attracted patrons like Del Monte.

The Fortune Teller

Patronage of Cardinal Francesco Del Monte and Caravaggio's Bohemian Behaviour 1595–1600

Some time around 1595, Caravaggio's innovative work caught the attention of Cardinal Francesco Maria Bourbon Del Monte, whom Baglione called an 'art lover': 'On this occasion [when Valentino arranged to sell a few of Caravaggio's paintings] he made the acquaintance of Cardinal Del Monte who, being an art lover, took him into his house.' Apparently one of the first paintings bought by Cardinal Del Monte was *The Card Sharps* (*I Bari*). This patronage came at a time when Caravaggio needed help most and no one provided more assistance in the artist's life than this unusual prelate. Bellori suggests that Caravaggio was tirelessly promoted by artist friend Prospero Orsi, who 'by acclaiming Michele's new style, increased the renown of his works to his own advantage among the persons at the court.' Bellori also details the event with a discussion of Caravaggio's 1594–95 painting *The Card Sharps*: 'The picture was bought by Cardinal Del Monte, who being a lover of painting, helped Michele out of his difficulties by giving him an honoured place in his house among his gentlemen.'

His own life being quite complex, Cardinal Del Monte (1549–1626) was one of the most sophisticated prelates in Rome. He was a noted antiquarian humanist and art collector involved in connoisseurship, the arts and music, as well as a diplomat and intellectual of the highest order. No less a person than the great artist Titian was Del Monte's godfather at his christening in 1549. Del Monte was raised and educated in Pesaro where his circle included the soon-famous poet and playwright Torquato Tasso (1544–95), author of *Rinaldo* (1562) and *Gerusalemme Liberata*

(1581). Del Monte's education combined Classics and Humanism with Christian traditions. He was originally from a noble Umbrian family connected to the Bourbon family of France. By 1595 Del Monte was well entrenched in Rome and also represented Medici and Tuscan interests in Rome's labyrinthine competing powers. He was selected as a cardinal to follow in Ferdinando de Medici's footsteps when he became Grand Duke of Tuscany in 1588. Del Monte was by no means among the wealthiest of cardinals in his day, according to the standards of the great families in Rome. He lived in a Medici palazzo (Palazzo Madama) in Rome in the parish of San Eustachio just around the corner from the Church of San Luigi dei Francesi and the studio where Caravaggio's paintings were being sold.

The cardinal's own noble brother Marchese Guidobaldi Del Monte was a mathematician and teacher of Galileo, whom Cardinal Del Monte also came to know by having him

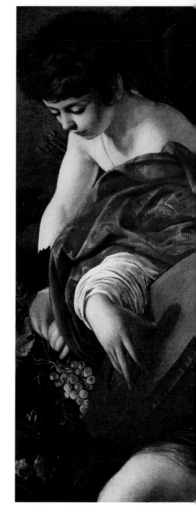

Musicians

as a frequent dinner guest in his household. It is not implausible that Caravaggio met him here. Cardinal Del Monte maintained academic interest in Neoplatonism and belonged to the *Accademia*

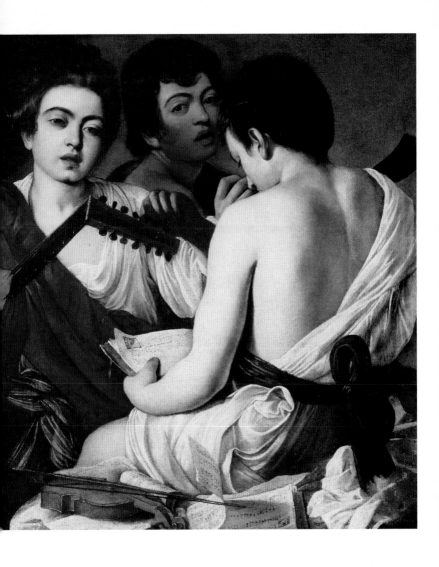

degli Insensati and as a classicist enjoyed both allegorical and symbolic references which he would encourage in the art he commissioned, along with alchemical and esoteric mythological allusions.

'It is not known where Del Monte grew up, only that he studied law and humanities. His father Renieri (1516–87) found a wife and later built a palazzo in Pesaro. The family background was in the duchy of Urbino . . . Renieri was indeed the Duke of Urbino's most trusted associate . . . Renieri's oldest son, the future scientist Guidobaldi [Cardinal Del Monte's brother] received as a bride one of the duke's two natural daughters . . . Renieri may have been the duke's working commander of troops . . . The careers of all the male Del Montes were military or churchly.' (C. E. Gilbert, *Caravaggio and his Two Cardinals*)

Most likely after buying some of the early paintings of Caravaggio, Cardinal Del Monte took the young artist into his service and household in 1595 in Rome and provided him with both income and room and board on a level that Caravaggio had probably never enjoyed since leaving home. Here he held 'an honoured place', in Bellori's phrase, in a wealthy household where art was supreme.

Perhaps among the favourite subjects of Cardinal Del Monte, a musician himself and a guitarist in his youth, Caravaggio's *Musicians* (1595) and *The Lute Player* (1595–96) were soon painted at the cardinal's request, although the first and better version is for a Genoese noble acquaintance in Del Monte's connoisseur circle, the Marchese Vincenzo Giustiniani. Baglione mentions *Musicians* as the first work Caravaggio painted expressly for Del Monte: 'Now that he had a home and an allowance, he gathered his courage and his reputation and painted for the cardinal youths playing music very well drawn from nature . . .'

Probably acknowledged by his prelate peers as the most musical among them and thus holding such offices as both obvious community choice and personal preference, Cardinal Del Monte was the cardinal capo in charge of reforming *Caeremoniale Episcoporum* church music for the liturgy of the Papal Congregation. This reform included a forward-looking mode in a modernizing style that borrowed fashionable bittersweet love songs, courtly love *canzoni* and *mandriali* of Monteverdi (1567–1643) and Giulio Caccini

(1546–1618) or even those popular *Amoretti* of John Dowland (1562–1626) or Thomas Campion (1567–1620) translated into Italian as well as musicalized Petrarchan sonnets adapted for church use. Song tunes could also easily filter to Rome from the lively *amore* traditions in Naples or Venice and be applied to hymnody when harmonized for voices. Del Monte was also the Cardinal Protector of the male Capella Sistina Choir.

Musicians (around 90 × 116 cm) is not only a music lover's auditory feast but may also exemplify Del Monte's esoteric Classical knowledge of Apollonian and Dionysian complements and Neoplatonic philosophy. Probably some kind of allegory, three musicians not dressed in any contemporary fashion but *all' antica* are readying themselves to play, one tuning his lute, another reading a musical score with his violin and bow resting on other pages, and a third in the background looking out at the viewer. His cornetto's curved horn bell sticks out from behind the shoulder of the musician with his back turned to the viewer. This musician looking directly at the viewer is often said to be a self-portrait of young Caravaggio himself. The parted lips and slightly open mouths of the two musicians facing frontally could be an allegory of the sense of sound to go along with the instrument tuning, likely if they are also going to sing *mandriali* (madrigals). The musical instruments shown are probably those of the cardinal's personal collection of over 37 including lutes, guitars, various sizes of *flauto dolce* (recorder), *spinettina* and viol found in the inventory at his death. It may be important to note that the double seven-stringed lute shown could allude variously to Apollo's kithara, Sapphic song (generally Aphrodite-related) or Pythagorean heptachord harmony (noting Del Monte's brother

Anonymous description of Cardinal Del Monte in 1603 (from Waźbiński, 1994)

Monti is a gentleman, a fine musician, a ready joker: he takes the world as it comes, has a thirst for life, and has friends in the world of letters.

Guidobaldi's mathematical side). The theme of love resonates in the young Cupid, whose hidden quiver holds at least seven arrows. Fruit has not altogether disappeared from Caravaggio's still life training because the Cupid is plucking grapes – just as a lyre was plucked – giving a Dionysian feel and the commonplace that wine and love complemented each other. His iconography was now becoming increasingly complex, probably because of many conversations with Del Monte.[12]

Baglione continues after describing the *Musicians* with 'and also [he painted] a youth playing a lute. Everything in this picture looked alive and real, most notably a carafe of flowers filled with water in which one could easily distinguish the reflection of a window and other objects in the room. On those flowers was fresh dew, rendered with exquisite accuracy. This, Caravaggio said, was the best picture he had ever made.' The first and better version of his *Lute Player* (94 × 119 cm) under discussion is the one painted for Vincenzo Giustiniani, now in St Petersburg, the second version being the one made for Del Monte and now in New York. There are several resemblances between the young man in the earlier *Boy with a Basket of Fruit* and this *Lute Player*, sufficient for many to query if they are both portraits of Mario Minniti, Caravaggio's Sicilian artist friend. Caravaggio cer-

tainly had ample contacts with Minniti and they had apparently lived together off and on or shared artist quarters.

In the *Lute Player* Caravaggio went to considerable lengths to make the music on the page clear, again probably at the commissioner's request. The musical text is that of Jacobus Arcadelt, a

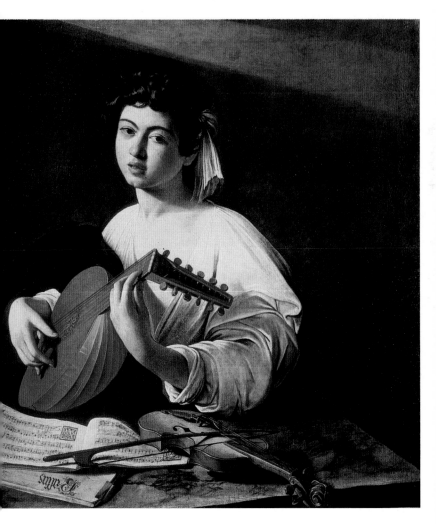

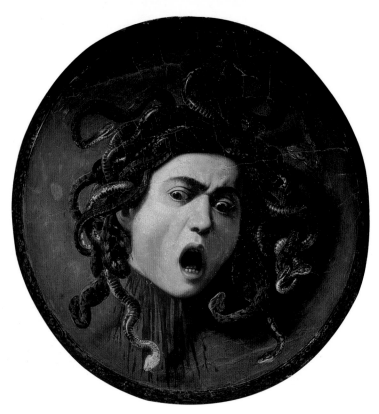

Medusa

northern composer of madrigals who must have been popular with both Giustiniani and Del Monte, both of them were possibly performers and singers of these songs. The text in the earlier Giustiniani version shows the initial lyrics of *'Voi sapete ch'io v'amo, anzi v'adoro'* ('You know that I love you, no, I adore you . . .') beginning with the engraved and illuminated V, from a love song published in 1539. The androgynous boy is not looking directly at the viewer but abstracted to his left (viewer's right) as if in introspection about love – itself a philosophical elevation. Much

has been made of the boy's loose white blouse (Classical and even possibly titillatory to some because it is opened on his chest) and the selections of table decorations which are colourful flowers in the vase and less colourful fruits (pear and fig) and vegetables (including squash) on the table. Ephemera of love in this life is a possible theme, with a tentative suggestion to look beyond earthly love. The colourful fragrant flowers – feeding the soul? – seem elevated above the less colourful but tasty fruit – feeding the body? Thus Caravaggio runs the sensory gamut from visual to auditory, olfactory, tactile (in strumming or plucking strings) and lastly gustatory. But beyond the visual quotation that is most direct, the auditory experience is apparently emphasized in this picture.

Medusa was a gift to Grand Duke Ferdinand I Medici around 1597 (and possibly later a wedding gift around 1607 for Prince Cosimo II Medici). Del Monte probably asked Caravaggio to render the severed Medusa head tondo on a canvas shield. Several precedents existed, including the lost Leonardo *Medusa* that had disappeared without documentation from the Medici collection inventories not many years before. The Medusa or *Gorgoneion* image was famous as a protective device on the Athena-Minerva aegis breastplates and also a sign of divine power and protection in antiquity. Cosimo Medici had at least one sculpted torso bust of himself wearing just such a breastplate as an emperor would wear, with Jovian eagle *epaulettes* and the *Gorgoneion* in the centre of the aegis. The connotations are logical, connecting Cosimo Medici with a powerful aegis and a metaphor for wisdom and divine protection over Florence. But Caravaggio's *Medusa* is far more frightening and emotive of horror than previous Renaissance images even without the snaky hair.

Caravaggio's Medusa expresses shock with her gaping mouth, grim brow and bulging eyes with the spurting blood reflected in the mirror, guard for the hero that reversed Medusa's power and

petrified the petrifying monster. As in Ovid's lines from *Metamorphoses* IV.655 ff. where 'Perseus saw both men and beasts turned into stone, all creatures who had seen Medusa's face. Yet he himself only glanced at its image – that fatal stare – reflected in the polished bronze shield . . . Even to the writhing serpents of green hair he struck her head clean from her collarbone.' It is also worth noting that this *Medusa* is one of Caravaggio's first decapitation scenes, soon followed by his *Judith and Holofernes* a few years later around 1598. It is also a probable self-portrait of the artist painted literally using a mirror as the shield would suggest.

The second *Bacchus* image Caravaggio painted, in his Del Monte years, is the more famous one, synthesizing many of the seminal events and the evolution of ideas in his life at this time. Painted circa 1596, this *Bacchus* is not a self-portrait like the *Bacchino malato* of 1593, which may be due more to Caravaggio's patronage and new financial wherewithal to hire models than to any question of identity or self-image. First of all the direct gaze of Bacchus is not so much challenging and confrontational as relaxed and slightly indolent while muscular. His critics noted – sometimes erroneously applied in reaction to other paintings as Baglione stated – the mastery of water flask and reflection of the studio window in it. Yet it is not his mimetic power of rendering nature that is noteworthy here or even the 'posturing' of a local youth as Bacchus but the juxtaposition of the ordinary with the extraordinary. The iconography of Bacchus is secure: vine, ivy, fruit and ivy wreath in his hair, and the wine glass offered, as if in a toast, to the absurdities the young wine god finds amusing judging by the faint smile. This is the Bacchus Caravaggio could follow in the taverns, brothels, and rowdy piazzas of the Ortacchio district. The picture doesn't have any provenance until 1618 when it came into the Medici collection for Cosimo II, Grand Duke of Tuscany.

At this time, Caravaggio lived with Cardinal del Monte in the Medici-owned Palazzo Madama just a few streets away from the

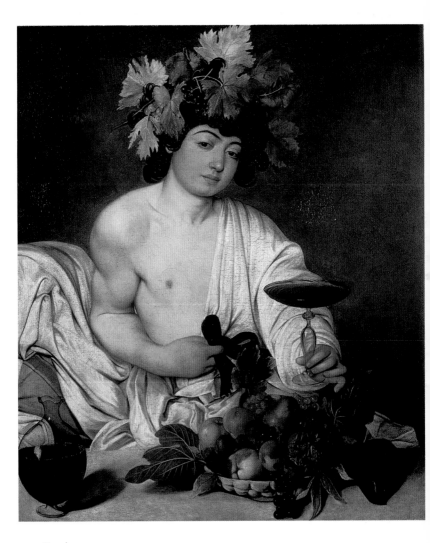

Bacchus

famous Roman Pantheon, also known then as Santa Maria Rotunda, and around the corner from the Church of San Luigi dei Francesi. Palazzo Madama was also just a few steps away from the Piazza Navona, the site of the Flavian Roman emperor Domitian's old racing circus. Thus both the palazzo and the Church of San Luigi are between the Pantheon and Piazza Navona. These landmarks are easily visible in a map of Rome from 1593 by Antonio Tempesta (an acquaintance of Caravaggio). The *rioni* (regions) of Rome were divided at this time into at least fourteen districts, and Palazzo Madama is in the San Eustachio district between the Pigna and Parione districts in the old imperial Roman region of Augustus' Campus Martius in the circular westward bend of the Tiber north of the Palatine and Capitoline hills. The Palazzo Madama had been built in the early sixteenth century by the Medici and occupied by both Medici cardinals before they became popes, Leo X (Giovanni de' Medici, son of Lorenzo the Magnificent) and Clement VII (Giulio de' Medici). It was also the residence of Catherine de Medici before she became Queen of France. Del Monte was given the lease of the

palace after his cardinalship as the Medici's prelate agent in Rome.

Living in an apartment of several rooms in the Palazzo Madama, Caravaggio had the services of his own two servants and in some

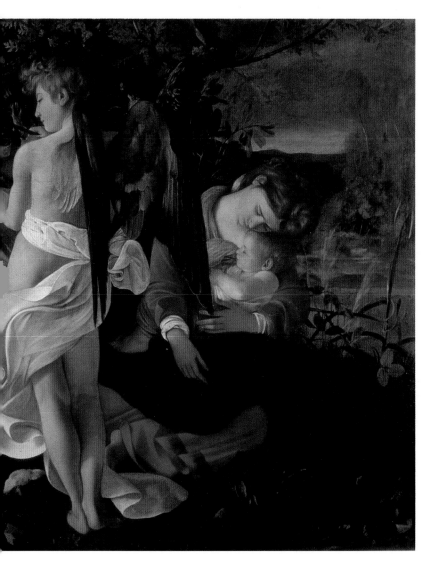

Rest on the Flight to Egypt

ways affected the manner of a gentleman, seemingly dressed all in black except for a lace ruff collar. While not necessarily a Roman dandy, for he is often decried for being slovenly dressed as well, Caravaggio could have begun to make social acquaintances on his own merit, and would not be above cultivating relationships with the type of women – those of unstable social class but equally ambitious as himself – for which the Ortacchio district was infamous.

One such woman was Anna Bianchini. Exactly where and how he met this courtesan is unknown, but he soon placed her in two of his most important paintings of this period. Anna may not have been the most beautiful of all courtesans but Caravaggio captured tender vulnerability and a capacity for suffering in subtle detail. The two paintings in which Anna Bianchini figured prominently are *Rest on the Flight to Egypt* (c. 1598) and the *Penitent Magdalen* (c. 1598), now side by side at the Galleria Doria Pamphilj in Rome where it can be easily seen the sitter is the same woman. Bellori said of the *Penitent Magdalen*, 'In a bigger picture he painted the Madonna resting on her flight to Egypt: there is a standing angel who plays the violin, while saint Joseph seated holds the music for him. The angel is very beautiful, turning his head sweetly in profile to display his winged shoulders and the rest of his nude body except for the part covered by a cloth. On the other side sits the Madonna, bowing her head and seeming to sleep with her baby at her breast.'

Rest on the Flight to Egypt (135 × 165.5 cm) is often described as Caravaggio's most peaceful work, as Spike mentions, in a rare 'lyrical mood', but appropriate for the Holy Family. Yet even this work is not without controversy. Part of the Advent and Nativity Cycle, one of the earliest surviving sub-narrative representations of the rest is a medieval example from the Church of St Martin, Zillis, Switzerland, circa 1120. This flight episode is part of that gospel narrative from Matthew 2:14 but both the

thirteenth-century *Legenda Aurea* of Jacobus de Voragine and the early fourteenth-century *Meditationes Vitae* by Pseudo-Bonaventura or Giovanni de Caulibus refer to much earlier Apocryphal literature. The traditional iconography is simple. Caravaggio adds a youthful angel playing a violin, in 'one of Caravaggio's dominant characteristics: his creation of a new iconography' as an 'unprecedented inclusion'.[13] Angels were traditionally thought to minister to the Holy Family en route to Egypt – since one had just appeared to Joseph in a dream (Matthew 2:13) warning of the danger to the Child – and even painted into the story, hence this old image reclothed, but not in this musical manner. From the Apocryphal narrative of the Late Roman Pseudo-Matthew 20 where the Holy Family rests at the roadside, this scene is a popular pastoral variant of the larger flight narrative in earlier paintings by Titian (c. 1512), Tintoretto (c. 1583) and others, even though much earlier St Jerome rejected these Apocryphal accounts whose picturesque qualities appealed directly to artists.[14] The familiar donkey is almost hidden in the background between Joseph's balding grey head, with a highlight shining on his alert eye, and the oak tree – so often a symbol of fidelity as well as the probable tree of Christ's cross – and the violin and the angel's light-filled profile. Bellori's description of the 'beautiful' angel is noted as a homoerotic insinuation.

The rare glimpse of a near Lombardic landscape – perhaps only one of two surviving landscapes if one considers the background of the later *Sacrifice of Isaac* (1603) – is part of a formula where the angel divides the human stone-filled half with old Joseph and the Edenic part with Mary and Child. Bellori said Mary had her head bowed, which is a good observation, and she could be seen as intentionally ambiguous in prayer without being sentimentally pietistic, although Caravaggio is just as likely to have intended the 'bowed head' to be read as exhausted sleep. This duality between the two parts of the painting is also a marked division

between a shortened narrow view behind Joseph where the dark forest looms and the calmer, more open distance behind Mary with a horizon of low hills. The touching intimacy between tired sleeping Mother and Child is one of the sweetest in art where Mary's cheek rests on the baby nestled protectively in her arms. If Mary is troubled at all (there is an unmistakably furrowed brow on Anna Bianchini), the calm of the Child may be a healing salve. The musical text held up by Joseph for the angel to read has long been identified as a motet by Noel Bauldewyne published in 1519 of several verses including *Quam pulchra es et quam decora* ('How lovely and fitting you are') from the biblical Song of Songs. Part of the controversy lay in the sensuality of the angel, seen here from the back, whose buttocks appealed to some as a flag for homo-eroticism. Even if this was possible by ambiguity it could be just a sort of red flag waved by the insolent Caravaggio. More likely the musical angel was a visual and political rebuke to the Farnese's favourite court painter Annibale Carracci (who had recently por-trayed music as a vice) along with the Spanish-siding Farnese family, which would not have sat well with Del Monte or Caravaggio and the aesthetes of their French-siding Medici and Aldobrandini circles.[15]

The *Penitent Magdalen* (122.5 × 98.5 cm) from the same year is another painting with Anna Bianchini as model and was also much discussed by Caravaggio's contemporaries and critics. Mary Magdalene was the ultimate symbol of the Counter-Reformation and Baroque era in her sinner-to-saint transformation and much adored by women whether pious matrons or equally thoughtful courtesans. Bellori could not refrain from criticism where he saw a posture for a religious theme rather than a truly religious paint-ing: 'He painted a young girl seated on a chair, with her hands in her lap in the act of drying her hair; he portrayed her in a room, and, adding a small ointment jar, with jewellery and gems, on the floor; he pretended she was the Magdalene. She leans her head a

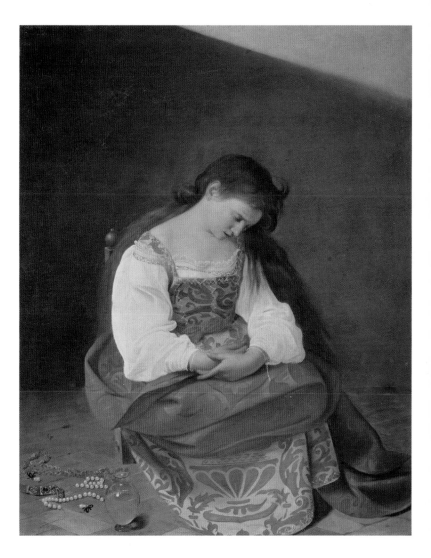

Penitent Magdalen

little to one side and her cheek, neck and breast are rendered in pure, simple, and true colours, in keeping with the simplicity of the whole figure; she has her arms in a blouse, and her yellow gown is drawn up to her knees over a white underskirt of flowered damask. We have described this picture to point out Caravaggio's naturalistic practices and imitation of true colour with just a few tones.'

In a brilliant rebuttal to Bellori – and surely Caravaggio appreciated this irony – what better person to model a prostitute than a prostitute? Bellori and many others clearly missed this point. No pretension was needed. On the other hand, Caravaggio seems to be avoiding the kind of titillatory sensuality of earlier half-nude Magdalene-as-Venus figures since the new church polity was 'extremely concerned with decorum and chastity in art and ritual' as Mormando opined. For many, 'the Baroque Magdalene became the "goddess of love", the "Venus of Divine Love" . . . [from] transmutation in Italy in the early sixteenth century' as the 'seventeenth century might be called the Magdalene's century' in Dillenberger's words.[16]

While Cardinal and previously heretic-punisher Archbishop of Bologna Gabriele Paleotti's 1582 treatise *Discourse on Sacred and Profane Images* on what was proper in sacred art as an outgrowth of the Council of Trent severely criticizes use of *figuri nudi e lascivi* and especially *concubini* or *meretrici* (prostitutes), Caravaggio cleverly follows the letter of the law while somehow mocking the spirit thereof.

Caravaggio paints the Magdalene possibly ambiguously, choosing the moment after she has loosened her hair (generally a provocative act in which a courtesan would have prepared to bed a client-lover, but here in preparation to wash Christ's feet). Bellori's comment about her 'drying her hair' is likely to be Caravaggio's clever anticipation of the woman who washed Christ's feet with her hair as an act of devotion. Her jewellery also bears inspection.

Pearls – shell-derived from the sea – are another reinterpretation of a Classical attribute of sea-born Venus as goddess of love, as are both perfume and bathing. These show Caravaggio's slight awareness of Classical iconography for models in Cardinal Del Monte's *Antiquarium* and the Giustiniani Collection.[17] How much Caravaggio knew of Classical antiquity is confused by Bellori's infamous anecdote noted above, where the artist preferred mimesis of nature to mimesis of convention.

In the Renaissance and Mannerist world a Jewess could be identified by mandatory pierced-ear loops or earrings. Mary Magdalene exhibits a clear piercing of her earlobe.[18] The pearl necklace that she once wore around her neck was broken in two sections, perhaps to show the abandonment of her life as courtesan. Curiously, there are 36 pearls total in the two strands and the break occurs between 20 and 16 or 16 and 20, meaningful given the projected chronology where she encountered Christ in her prime at 20 years old and later lived beyond her conversion another 16 years. Alternatively, Puglisi refers to a tradition which had her living as a hermit for the last years of her life, which could also be applicable here, and the *Legenda Aurea* states the Magdalene and many other disciples migrated to Marseilles 14 years after Christ's Passion, which could yet also give meaning to the strand of 16 pearls as her conversion was some time before Christ's trial and crucifixion according to all the gospel accounts cited earlier. Even her *barocco* earrings are shaped similarly to her body form. The chains she has discarded echo the medieval iconography of the *La Dame à la Licorne* tapestries where cast-off necklaces symbolize sensual renunciation and denial of the passions. Perhaps the gold chain could represent the discarded and broken sensual life and the white thread around her wrists could represent the new pure life she intended to follow as an ascetic.

In 1597 Caravaggio also painted his only known fresco of oil on plaster for Del Monte, a mythological or alchemical allegory of

Jove, Neptune and Pluto on the ceiling in the Cardinal's small private *Casino* in the Villa Ludovisi Boncompagni of the Ludovisi Gardens in Rome. While Caravaggio's apparent inability or lack of enthusiasm for frescoes kept many important commissions from coming his way, the success of this lone example of a popular medium is heightened by Caravaggio's masterful use of foreshortened figures as the mythological triad of brother gods who govern sky, sea and earth is meant to be seen from below and is remarkably realistic for such a shallow surface with all the perspective problems it posed. Bellori commented: 'In Rome they attribute to his hand *Jove, Neptune and Pluto* in the Ludovisi Garden at Porta Pinciana, in the casino which belonged to Cardinal Del Monte, who as a scholar of chemical medicines, adorned the small room of his laboratory, associating these gods with the elements with the globe of the world in their midst. It is said that Caravaggio, hearing himself blamed for not understanding either planes or perspective, placed his figures to be seen from below in order to prove himself equal to the most difficult foreshortenings. It is indeed true that these gods do not retain their proper forms, and are painted in oil in the vault, since Michele had never painted in fresco.' This fresco, seemingly the only surviving example by Caravaggio, was not rediscovered until 1969. Naturally, canvas was his preferred medium and who could match him in this? Another early patron Ottavio Costa, also a friend of Del Monte, had already purchased several paintings around 1598 including a *St John the Baptist*; he would commission other pieces in this period including the *Conversion of the Magdalene* (or *Mary and Martha*) scene with Fillide Melandroni as Mary.

Luca, a barber whose apprentice was reputedly assaulted by Caravaggio in July 1597: 'He was a large young man, around twenty or twenty-five years old, with a thin black beard, black eyes with bushy eyebrows, dressed in black, in a state of disarray, with threadbare black hose and an unruly mass of black hair long over his forehead.'

Often seen dressed in fancy black clothes which he could then afford with the commissions generously sought or advanced by Del Monte and his circle of friends like Marchese Vincenzo Giustiniani of Genoa, Caravaggio could apparently move freely after evening concerts in the *Salone* of the palazzo or dinners with the cardinal and take leave to the streets with other young men carrying swords. Bellori offers evidence of Caravaggio's odd mix of dandy and bohemian life: 'We must not forget to mention the way he behaved and dressed. Although his clothes were made of the finest materials and velvets, when he had put on one outfit, he never changed it until it had fallen into rags. He was very negligent in his personal hygiene and he ate for many years on the canvas of a portrait, using it as a tablecloth morning and evening.' These clothes were probably more a result of his commissions than his allowance from Del Monte. It would be unlike him to change his dress between Del Monte's dinner table and the street below. This roaming around at night in Rome is where he seems to have sought, or was careless to avoid, danger in the form of roving bands of *bravi* who might fight with the *shirri* police. Many of the *bravi* were unemployed veterans of wars who were now an embarrassment to the feudal lords of Rome. It was a political tinder-keg that Rome's prelates and aristocrats preferred to ignore and wished would go away, but the Ortacchio district attracted them like flies. While it was illegal to wear a sword without a permit, many *bravi* would flaunt the privilege as if they were gentlemen. Duels for honour were a scourge on the city, and countless scuffles and punctured bodies were due to the pride of these *bravi,* which must have resulted in mass homicidal attrition of young men in Rome between 1590 and 1610 despite the official bans on duels and public fighting.

In what was either his first or second arrest for disorderly conduct, the local *shirri* police apprehended Caravaggio for wearing a rapier without a permit. The location was right around the corner

from Del Monte's residence. The magistrate records thus '4 May, 1598. Bartolomeo, Deputy of the Chief Constable of Rome reports to the notary of Tor di Nona Prison: . . . yesterday when making the rounds through Rome between the hours of two and three of the night [or 10 and 11pm], when I was between Piazza Navona and Piazza Madama, I ran into Michelangelo da Caravaggio who was carrying a sword without permission and a pair of compasses, and so I seized him and imprisoned him in Tor di Nona Prison.'

Hauled before a magistrate, Caravaggio testified on his own behalf in response to questioning at the prison: *for myself and my servant, and lodging in his house as well. I am registered in his service. I was seized yesterday at about the hour of two in the night between Piazza*

'He had only one brother, a priest, a man of high morals, who when he heard of his brother's fame, wanted to see him and moved by brotherly love, went to Rome . . . Being aware of his brother's eccentricities, the priest thought it best to explain everything to the Cardinal [Del Monte] first. This he did and was asked to return in three days' time. In the meantime the Cardinal called Michelangelo and asked him if he had any relatives; he answered that he had none . . . On being confronted with the priest, he said he was not his brother and that he did not know him. The poor priest, in the presence of the Cardinal, said tenderly, "Brother I have come from far away only to see you, and having seen you, I have found what I was looking for, for I am, as you know, in such a position, thank God, that I do not need you for myself or for my children. Instead it was my hope, if God would allow me to arrange a marriage for you, to see you with children . . . May God help you to do good, as I will implore His Divine Majesty in my prayers, and as I know that your sister will do in her chaste and virginal prayers." Michelangelo being unmoved by these words of burning and bright love, the good priest left without even receiving a godspeed from his brother. Thus it cannot be denied that he was extremely crazy and that, owing to this strange behaviour, he shortened his life by ten years or more.'

Madama and Piazza Navona, because I was carrying the sword I usually carry, being the Painter of the Cardinal Del Monte, and getting a salary.

The subtle differences or nuances of the two testimonies of the magistrate and the artist deserve amplification. The time and place are in agreement as is the crime of wearing a sword. It is late at night and the order of places is reversed in the two accounts, suggesting the magistrate was walking northward from the Piazza Navona where Caravaggio seems to have been walking southward from Del Monte's house which he may have recently left, although this departure is conjecture. However, Caravaggio amplifies several details not in the policeman's account. First, while the magistrate calls it a single sword-carrying without permit, Caravaggio divulges that he usually wears it and is thus in a habitual law-breaking mode. Could this same or other magistrates have stopped Caravaggio before and only given a warning?

The magistrate records the artist's full name very precisely as Michelangelo da Caravaggio whereas Caravaggio cites Cardinal Del Monte's name as a sort of trump. This would require a possibly galling admission of needing a patron or that his own name was insufficient while at the same time appearing manipulative in titling himself 'the' painter as in 'sole' painter of the cardinal. Furthermore, although it appears not to be asked, Caravaggio supplies the detail not only that he lives in Del Monte's house but that he has a servant – thus a gentleman of sorts and possibly therefore somehow entitled, however tenuously, to wear a sword.

Published in 1604 while in Rome, the Haarlem painter Karl Van Mander had written an unfavourable account about Caravaggio around 1600 that the artist would paint seriously for a fortnight and: 'then swagger about Rome for a month or more with his swords swinging at his belt and his servant following faithfully, going from one ball-court to the another, always eager to fight or argue, with the result that it is always awkward to get along with him.'

Gentlemen retainers of lords could wear swords if they themselves were both either gentlemen or guards of that lord. Caravaggio may also be implying by both getting a salary and being 'registered in his [Del Monte's] service' that he was not only a household member of standing but had legal protection and licence from the cardinal by being so 'registered'. Although he may not be subtly threatening the police with the legal power of the Church by name-dropping Del Monte in his defence, his answer appears to give more information than was requested, exhibiting a pride of station. This is the first fully documented account of an arrest of the artist and suggests that after two or so years in the service of Cardinal Del Monte, Caravaggio believed he had a leg up in the world to flaunt a dubious privilege before the law. This stay in prison was of probably no more than a few days.

Criminals and Courtesans and the Question of Caravaggio's Ambiguous Sexuality 1595–1600

Criminals and courtesans seem not to mix well in modern opinion with connoisseurs and painters of great religious genius, but all are present in Caravaggio's case. How did Caravaggio's volatile art and life mix? Between 1595 and 1600 Caravaggio began to become bolder in his painting and lifestyle. The mixed testimonials of Caravaggio's art – philosophically and creatively innovative while provocative in choice of models, iconography and subject treatment – are not necessarily at odds with the often abject, violent facts of his short life. Looking for dramatic clues to the passions in his life, one can easily find similar violence in many of his paintings. Perhaps the best analyses to date include those studies that show how Caravaggio was not removed from but in fact involved in the Counter-Reformation culture of his day with its public spectacles of hangings and beheadings and its emphasis on martyrdom with all the gory details. As Varriano and Seward have shown regarding violence in Caravaggio's art: 'the occurrence of violent themes in his painting strictly adhered to the established pictorial norms of his day' and 'gruesome emphasis on Christ's suffering reflects Tridentine decrees on art which urged artists to stress the reality of the gospel story'.[19] Caravaggio's paradoxical culture of austere and yet pugnacious religion and its Inquisitional penchant for bloodshed and *auto-da-fé* is complicated and not easily understood by his own or subsequent generations.

Caravaggio possessed a nature that was not easily subdued. His frequent fighting and sword-blustering suggest a bad temper and

a short fuse, mixed with a fiery pride. As Baglione put it, 'Because of the excessive ardour of his spirit, Michelangelo was a little wild, and he sometimes looked for the chance to break his neck or to risk the lives of others.' That he was habitually reckless and a great risk-taker with little regard to his future when not painting is indubitable. The many legal crossings and jail time suggest either a man who thought himself above the law and outside its bounds as if it did not apply to him or someone so proud or incapable of self-control that passion was stronger than reason. This seems at odds with the discipline required to paint as he did. Knowing his own genius made him unique would not have helped – indeed it possibly aggravated his situation. His associations, when not painting, included both connoisseurs and criminals. Baglione continues: 'People as quarrelsome as he were often to be found in his company', especially in the brothel and tavern-filled Ortacchio district of Rome where outlawed swords were as common as outlawed prostitutes, neither easily enforced in the wild quarter. By choice and by temperament, all could appeal to his personality: connoisseurs could appreciate his genius, duly heaping on him praise and respect for his art; criminals could appeal to his lawless pride and prostitutes to his lust for life.

All three of these types of Roman personality in his life – connoisseurs, criminals and courtesans – were portrayed in his paintings, but the prostitutes became his intimate companions. He is certainly not the first nor the last to portray a beautiful courtesan as the Virgin Mary. In 1451, most probably at his noble commissioner's request, Jean Fouquet portrayed a busty, bare-breasted Agnès Sorel, the mistress of King Charles VII of France as the ultimate Mother of God. If Sorel's piety and high morals had not been well known to her own society, hers would have been an unlikely portrait. Vicarious cheesecake *pornographia* (in the ancient Greek sense, 'depicting a prostitute') masked as religious piety fools no one. Yet Caravaggio's repeated prostitute models such as

Anna Bianchini, Fillide Melandroni or Maddalena Antonietti, simply known in Caravaggio's circle as 'Lena, Michelangelo's girl', rarely convey full-blown sensuality although they might sometimes evoke lust. The relationships with these three known courtesans, whether merely professional as his models or more personal as is implied with Lena, seem to be in this order: Anna Bianchini around 1595, Fillide Melandroni from somewhere between 1597–99, possibly up to 1602, and Maddalena Antonietti around 1604–05.

What else can be said about the prostitute Anna Bianchini? She must have been acquainted with Caravaggio sufficiently for him to depict her twice in succession. His artistic use of her as model

'The subject matter of [Caravaggio's] painting . . . raises once more the most general and pressing objection against his work: that characters encountered in the street or taverns of ill-repute were not worthy to be included in the canon of 'authorized' subjects.'
Longhi (1968), 55

pre-dates that of Fillide Melandroni. Yet she cannot be found with certainty in any other of his paintings. Although there is no obvious eroticism associated with Anna Bianchini in his art – as if he did not find her desirable himself or would not render her thus, unlike Fillide – her maternal nature comes out in the *Rest on the Flight to Egypt* picture just as her emotional depths emerge in the *Penitent Magdalen*. Anna Bianchini may be the other girl as Martha opposite Fillide's Mary in Caravaggio's *Mary and Martha* (1598–99) known also as the *Conversion of the Magdalen*. In both paintings there is a degree of hardship identifiable in her facial features with which Caravaggio clearly sympathizes. She appears quite young in the paintings, perhaps 16, as Bellori indicated by his choice of the word 'girl'. She might have been the vulnerable kind of *cortigiana* who seemed to visibly suffer in her choice of life, not at all the hardened veteran of the streets of the Ortacchio who would be counting the spurs of her paid lovers to see how far into propriety they could pull her. If Caravaggio didn't portray her as

St Catherine of Alexandria

an object of lust, at least he immortalized her tenderness, humility of character and capacity for suffering.

Fillide Melandroni was the other prostitute and main model Caravaggio employed for new dramatic poses such as in *St Catherine of Alexandria* (1599). Fillide had a clientele among higher social circles including churchmen and nobles such as Giulio Strozzi from Florence. Possibly originally of mixed Greek and Italian descent judging by her name *Melandroni* (Italianized Greek for 'tuna' or 'dark men'?) like many Neapolitans and Calabrese or indeed a great number of southern Italians, Fillide also had a Greek first name (*Phyllis*), originally belonging to her famous courtesan counterpart, who played Aristotle for a fool in legend. Probably born around 1581 in Siena, Fillide had moved to Rome and climbed rapidly up the social ladder, keeping her own house in the Ortacchio district where she entertained a better quality of admirer than most courtesans. If she appeared anything close to the proud and strong young woman Caravaggio paints her as, she must have been a man-killer in more ways than one. She is also the most likely model for Judith in Caravaggio's *Judith Beheading Holofernes* (1598). It is no coincidence that Fillide holds a sword in both of these first two paintings, as Catherine and Judith, playing the role of a *femme fatale* in Judith where as Catherine the virginal saint's pose changes the story somewhat. Varriano has also noted that Judith's nipples under her blouse are erect as if aroused by the connection between violence and eroticism, even though she may be repulsed by that and her task, which would be very observant of Caravaggio.[20] That a sword is so often a play on a phallic image is reinforced by the etymology of macho and machismo, both deriving from *mach-* (or *machaira*) for sword. It is also very likely that the sword depicted is none other than Caravaggio's own ill-reputed blade, more a long rapier or duelling sword than an executioner's broadsword. As Catherine, Fillide appears to be running her fingers along the

sword blade in a gesture that may not be so innocent. It is a coquettish toying with a weapon, a suggestion that seems inescapably to imply sexual punning of some sort.

Caravaggio's most often used female model, Fillide also appears in other paintings including her portrait – it was in Berlin and is

Judith Beheading Holofernes

now lost but is still known from pre World War II photographs – and *Conversion of Mary Magdalene with Martha* commissioned by Ottavio Costa. His Catherine painting is one of the first to receive full note of its *tenebrism* as a style with its use of darkness as if painted more by night and candlelight than daylight. Even

Bellori commented on this: 'Saint Catherine on her knees leaning against a wheel . . . showing a more saturated colouring, as Michele was already beginning to strengthen the dark tones.'

How well and in what way did Caravaggio know Fillide Melandroni? Did he merely employ her as a model or, since he was of similar relative social status (both of them being ambitious social climbers with obvious but very different gifts), did they share the same bed, as models and artists often did? While it is not unlikely that Caravaggio could have enjoyed Melandroni's sexual favours if they were ever more than just friends, it is more likely he could not have afforded her as

she was one of the most-sought after prostitutes in Rome. She was used to more lavish compensation than a rising artist could provide. The wide-eyed way Fillide looks out as Catherine – alert rather than apprehensive of impending martyrdom – and the manner in which she holds 'his' sword provoke one to wonder if Caravaggio was boasting of something more than a casual sitting. If so, this could soon be explosive if any potential 'rivals' of the nobility suspected or were jealous of Caravaggio's relationship, especially since they – like Giulio Strozzi, her favourite of the young aristocrats from whom she received gifts and money as well as possible devotion – would consider the artist beneath them just as archly as Caravaggio would consider himself at least equal to them. Was Fillide using Caravaggio as he used her? She was apparently canny enough to encourage Caravaggio to paint her, producing a kind of immortality or at least a kind of advertisement of her as a most important *cortigiana*.

Very little can be reconstructed about the third prostitute, 'Lena' other than her name Maddelena Antonietti. 'Lena, who stands in Piazza Navona . . . who is Michelangelo [Merisi]'s girl.' Maddalena Antonietti was a prostitute from a well-known family of several generations of Roman prostitutes, with a sister Amabilia who was also a prostitute. That she was known for habituating a place noted for prostitutes seems to underscore her profession as a street girl. This very manner of advertising her life suggests a lower type of courtesan than Fillide Melandroni who did not need to stand in the street because she had her own house. Lena may have been the most accessible woman Caravaggio could have, certainly the kind he could expect to afford. Her name is interesting because of its immediate association with Mary Magdalene, the most likely saint and protectress of Italian prostitutes, reformed or not. Lena is possibly also Caravaggio's model for the *Madonna of Loreto* (1603).

It is noted that men in Rome fought over courtesans like Fillide

and Lena frequently. Caravaggio himself is said to have later fought at least one man, a notary named Mariano Pasqualini, over Lena in 1605. The cause for this fight is unknown, but perhaps it was for love or pride. It would have been normal for men in the Ortaccio to feud over something as tangible as a woman used to dispensing and receiving favours for money; equally likely for a courtesan (*cortigiana*) to have incited men to compete for her attention in this machismo Roman venue known for violence and outré displays of male preening. Arrests rarely account for even a third of the actual illegalities, but nearly all prostitutes in Rome had lengthy arrest records if they were any good at all or were employed with any regularity in their short careers of ten years or so when they could boldly flaunt their physical beauty. If they started at age 16 or so they might stretch their earning years by a decade, especially if they found protectors or patronage in wealthy admirers among the higher social classes. Once such a woman was brought to a nobleman's banquet or party, it would be hard for her to ever have such ease of access again to other circles of influence.

That Caravaggio cultivated and knew this kind of woman best is fairly obvious: courtesans were the usual models and sometimes companions for painters anyway. Whether or not he was intimate with 'Lena' is less circumstantial than it might appear. She would have been his most likely female companion just as Anna Bianchini may have been a decade before her, whereas Fillide certainly had known patrons of a much higher station than Caravaggio.

Caravaggio's possibly ambiguous sexual preferences have been hotly debated for years, but it is unlikely to be a resolvable issue based on knowledge now possessed. The case could be made either way, depending on the evidence regarded and inference allowed. Cardinal Del Monte himself was also criticized posthumously by Theodore Dirck van Ameyden, a seventeenth-century Flemish chronicler in Rome who was sympathetic to the Spanish as one of

their agents. Thus Ameyden was greatly hostile to the Francophile and Medici-dependent cardinal and his witness is now seen as biased. Ameyden called Del Monte a 'lover of boys' even though Del Monte was also involved in his youth as a guitar-playing serenader of aristocratic women and the cardinal reminisced with a friend in 1607 in correspondence about their 'honeyed moments with Artemisias and Cleopatras'.

According to some, the artist Caravaggio possessed at least one young male 'Caravaggino' who lived with him. Some put it more strongly, in 'facts that are known about his life: his early biographers make it quite plain that he was a homosexual'.[21] Other contemporaries like the artist Tommaso Salini, who was a friend of Baglione, alleged in 1603 during Caravaggio's libel trial that Caravaggio kept a *bardassa*, which can mean either a male prostitute or a low life companion, a serious charge of practising homosexuality which would have been a capital criminal offence. But Caravaggio denied in the court ever knowing the person involved (Giovan Battista) and the fact that Salini was Baglione's friend called as witness undermined his testimony to the court. Certainly many insinuations like these cropped up in Caravaggio's life. Yet, careful reading around what is offered of this 'established fact' of homosexuality show his sexuality is not so crystal clear. One of the only textual sources for this ambiguity was the English traveller Richard Symonds in 1650 who was told that the pre-adolescent boy Cecco (whose real name was Francesco Bonero) was the nude model for the Cupid in *Omnia Amor Vincit* (1601), also in the young nude *St John the Baptist* (1602) and elsewhere and 'was his own servant that laid with him', but this was never more than half-century-old hearsay, as were similar insinuations – less than a handful – from perceived enemies or detractors in his own day. If only the paintings from 1593–1602 are admissible, with their nude boys and sensual youths, this is certainly not enough evidence for homosexuality.

Similarly, the best case for Caravaggio's heterosexuality is almost equally an argument from silence except where it is noted as above that 'Lena' was 'Caravaggio's woman' and the many portraits of courtesans. At least three now lost female nudes of Caravaggio included *Susannah and the Elders,* a Classical myth subject of Danae who was impregnated by Zeus as a stream of sunlight – almost impossible to render without a lusty appetite if one accepts Klimt's voyeuristic portrait of Danae much later – and another *Penitent Magdalene,* but it is impossible to reconstruct from these how much he appreciated and was attracted to female beauty. Seward suggests Caravaggio had several mistresses, but this may be equally based on hearsay or tenuous grounds, although Caravaggio also seems to be historically linked with yet another *cortigiana*, a prostitute known as 'Menicuccia' whom some tentatively identify as Domenica Calvi but about whom we know very little.[21]

The most important clue to Caravaggio's sexuality is provided by his fighting with other men over a woman, including his above-mentioned quarrel with the notary Mariano Pasqualini in July, 1605 over Lena, whom he seemed to feel was his own woman, either as privileged client or some relationship much closer and more personal. It is unlikely that a homosexual painter would have engaged in this type of rivalry over a woman. But, on the other hand, if Caravaggio was bisexual, possibly preferring young males in his youth and females in later adulthood, he would not be very different from many of his age. Seventeenth-century attitudes to sexuality would not be as polarized as modern opinion, but at the same time gradual acceptance over the last few decades of personal sexual preferences has eroded former castigation of homoeroticism and homosexuals. Fairness should prevail here on any such questions of sexuality. Nowhere does Caravaggio state in surviving records public or private what his sexual preferences were. If his art is any gauge, it could go either way. But

sensational cinematic testimonials of the late twentieth century – such as Derek Jarman's *Caravaggio* of the 1980s – claiming Caravaggio to be 'the last sodomite', or as a champion of homosexuals are not only short-sighted, they are downright dishonest. Film directors mendacity may claim Caravaggio, but Caravaggio will have the last word even in silence.

Caravaggio's increasingly outré behaviour in the 1590s must have vexed his contemporaries as it did his early biographers. Every testimonial seems to note his excessive pride. Several other painters like Orazio Gentileschi were aware of Caravaggio's prickly personality and mercurial temper, and Baglione minces few words about Caravaggio's bellicosity and mocking tongue or pen. Gentileschi's 1603 deposition in the lawsuit for libel brought by Baglione carefully noted the ego of Caravaggio in that 'Caravaggio, although he is a friend of mine, waits for me to greet him first.' Seemingly stung by Caravaggio's derision of him, Baglione wrote of him, 'Michelangelo Merisi is a sarcastic and haughty man' and noted Caravaggio derided past masters.

These characterizations were not mere isolated observations from rival artists. Everything Caravaggio did in public reinforced these perceptions. There is no exact record as to why and when (1601?) he left Cardinal Del Monte's service, but while it may not have been an acrimonious separation, it is possible the Cardinal breathed a sigh of relief over this artist he described in as much truth as jest as having a 'strange brain' (*uno cervello stravagantissimo*) and being 'a complete eccentric'. He had certainly expanded Caravaggio's repertory and found him many commissions, and was still doing so but possibly with more detachment. Caravaggio may have also begun to find even a cosmopolitan cardinal's household stifling. Caravaggio could probably have afforded his own accommodation as his income by 1600 must have been equal to that of a fairly prosperous merchant. He would soon receive 300 scudi for the Contarelli Chapel paintings and Baglione jealously

mentions 'hundreds of scudi' which Ciriaco Mattei, brother of Cardinal Mattei, would pay Caravaggio for several paintings. After living with Del Monte between 1595 and 1600, Caravaggio would move into the palazzo of Cardinal Mattei from 1600 until 1601 even though Del Monte continued to support him with commissions through friends.

But in the autumn of 1600, probably October, Caravaggio was noticed by the law again. His friend Onorio Longhi was arrested for attacking another painter, Marco Tullio, and while Caravaggio was alleged to have drawn his sword, Longhi denied it with an added defence that Caravaggio was sick, too weakened to carry his own sword so that a servant carried it for him. Caravaggio had been present at the fight, to be sure, but had purportedly separated the two artists during fighting. A month later, probably in November of 1600, Caravaggio was again in trouble. He was accused of assaulting Girolamo Stampa, a Tuscan, 'with the flat of his sword' and multiple blows with his fist. Then two months later in February 1601, Caravaggio had to pay a settlement out of court to a retired sergeant of the Castel Sant'Angelo guard, Flavio Canonico by name, charged with armed assault for a probable swordfight. Unfortunately, this was an escalation in his encounters with police and prisons. It is estimated that between 1598 and 1605 Caravaggio would be hauled before the police at least eleven times.

What is more ironic is that Caravaggio was reaching his peak as an artist. Caravaggio's dramatic new style was now fairly well described by Bellori in several different passages: 'Since he aspired only to the glory of colour, so that the complexion, the skin, the blood and the natural surface might look real, he attentively directed his eye and work to this alone, leaving aside all the other concerns of art.' Here Bellori underlines the natural appearance Caravaggio strove after rather than the affected appearance of traditional conventions where harmonious composition was more

important than reality. Bellori adds: 'Therefore in finding and arranging his figures, whenever he came upon someone in town whom he liked, he was satisfied with that invention of nature without further exercising his brain.' This criticism would extend to Caravaggio's choice of persons off the street – including prostitutes and poor labourers who might even have been recipients of Caravaggio's compassion if he paid them anything – because they were real and not affected. The weary looks, aged faces with weathered wrinkles, and torn clothes in Caravaggio's paintings all add up to compassionate understanding of human weakness and common mortality. This may also suggest a more paradoxical humility than he is often credited with possessing, a contradiction with his bellicose brusque manner and often arrogant treatment of others. Caravaggio could have both a fiery temper as well as a rare appreciation of humanity.

But the clearest summation of Caravaggio's new style and his studio method is summarized thus by Bellori: 'Caravaggio was making himself more and more renowned for the colouring he was introducing, not as sweet and sparingly tinted as before, but reinforced throughout with bold shadows, using a great deal of black to give relief to the forms. He went so far in this manner of working that he never brought any of his figures out into the daylight, but found a way to paint them against the darkness of a closed room, taking a high lamp that hung vertically over the principal part of the body and leaving the rest in shadow so as to give force to the power of light and dark.' Thus his style and method are identified by his contemporaries in what will soon be called *tenebrism* (dark and shadowy effect) and his use of *chiaroscuro* (light and dark) in dramatic

'Identifying a Caravaggio has become a thrill for dealers and a risk for scholars. Yet exhibitions devoted to him have attracted many visitors. He has inspired a film by Derek Jarman, and one of the characters in Michael Ondaatje's *The English Patient* bears the name Caravaggio.' (Timothy Wilson-Smith, Caravaggio)

interplay between light and darkness. All these pioneering methods suggested by Bellori, along with an often brutal realism, intimate confrontational settings combined with innovative iconography and backgrounds reduced to minimal detail, a scorning of piety and a reliance on poor models as opposed to rich and powerful sitters are still what we can identify today in Caravaggio's art. For Caravaggio, simple nature and visual honesty are far more powerful than convention and hypocrisy. *Nature the only fit subject for my brush* as Bellori reconstructs Caravaggio's speech with his contemporaries.

With the Jubilee year in the following year (1600), Caravaggio was now entering his prime as an artist. In his 'Life of Matthew' commissions in Rome for the Contarelli Chapel in 1599 his first real church paintings would put his work before the public eye for the first time where all could see his originality in the *Calling of St Matthew* and the *Martyrdom of St Matthew*. These paintings in the Church of San Luigi dei Francesi were just around the corner from Palazzo Madama.

The Church of San Luigi dei Francesi was a major venue for Caravaggio's first important church paintings. The church was dedicated to Saint Louis, the Crusader King of France and was thus the official French church in Rome for French diplomats, clerics, nationals and pilgrims. The church was founded by a Medici pope, Leo X, and its foundation had been laid by Cardinal Giulio de'Medici (later Clement VII) but major building was delayed until 1580, long after the Sack of Rome. The great architect Giacomo della Porta was influenced by Michelangelo at San Lorenzo in Florence in his continued building of the San Luigi church façade beginning in 1580 under Pope Gregory VIII and continuing with Domenico Fontana's architectural plans, which had been commissioned by Catherine de'Medici who lived around the corner in Palazzo Madama before Del Monte. Fontana completed the church in 1589 and it was consecrated in the same year. Before Catherine such architects as Pellegrino Tibaldi and Jacopino del Conte completed other small chapels in San Luigi such as the Capella di San Remigio in the church in 1547. Artists who worked on the building include Giovanni da Sermoneta who had already completed Raphaelesque frescoes like the *Baptism of*

Clovis in the Capella Dupré of San Luigi around 1548. Later great artists such as Guido Reni and Domenichino would follow Caravaggio in painting at San Luigi in the next generation. The fact that Cardinal Del Monte represented Medici interests and French policy probably had much to do with Caravaggio receiving the commission just before the 1600 Jubilee on 23 July 1599. Such a conjunction of politics and art would many times henceforth both bless and cross Caravaggio.

With the important Jubilee fast approaching, Clement VIII expected a million pilgrims to come to Rome, and a flurry of finishing touches were needed in Rome to receive the large number. Painting in the Contarelli Chapel was commissioned through the rich estate of Matteo Contarelli, the French Cardinal Mathieu Cointrel, after his death in 1585. But the project had stalled with various artists until Del Monte seemingly lobbied Clement and the estate executor Abbot Giacomo Crescenzi on Caravaggio's behalf. Baglione records that 'On the recommendation of his cardinal he obtained the commission for the Contarelli Chapel in San Luigi dei Francesi, where over the altar he painted Saint Matthew with an Angel.' Baglione's identification is premature since the two sides of the chapel were to frame *The Calling of St Matthew* on the left and the *Martyrdom of St Matthew* on the right, and the later altarpiece painting of *St Matthew and the Angel* is from 1602.

In the painting of Matthew's calling, Caravaggio has hidden most of Christ's body behind Peter – an apparent reference to Peter's Roman preeminence and the restoration of France to the theological Roman fold in 1595 – and had the bony hand of Christ highlighted in the beam of light that also strikes the back of his head. Matthew is surrounded by a bunch of fops and dandies and echoes Christ's finger with his own self-referential querulous pointing as if to question the calling. Although this may be a theological sophistication beyond the ken of Caravaggio, some suggest

the gospel text of Matthew 9:9 where Jesus called Levi-Matthew to follow him may also somehow highlight the theological controversy between the Roman Catholic doctrine of Grace versus the

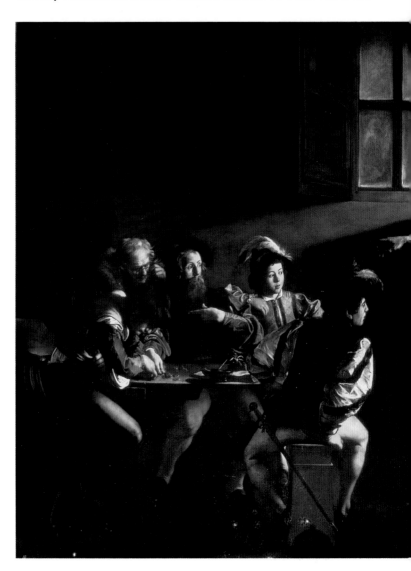

Calling of St Matthew

ation doctrine of Election alluded to in this
cture, the other older tax collectors or publicans
l because they are immersed in their money,
whereas the young boys are looking back
directly to Christ. Yet Matthew is the only
one responding, and even then somewhat
reluctantly. This may echo Christ's words
that 'many are called but few are chosen'
(Matthew 20:16), and suggest a manifesta-
tion of the middle road between Grace and
Election where the light of revelation
pierces a dark Roman backroom. Matthew
may have a choice, but we already know
how he will respond to the magnetism of
the call. Light has fallen on him.

The *Martyrdom of St Matthew* painting
set in Ethiopia is drawn instead from
Apocryphal tradition rather than gospel.
This Ethiopian version of his death is also
seen in a south aisle mosaic at San Marco,
Venice, and in Spain in the Pamplona
Bible (Bibliotheque de la Ville, 108, folio
210vo).[23] The Ethiopian version usually
shows Matthew about to be beheaded by a
sword, a theme repeated so often by
Caravaggio it almost becomes expected
and programmatic. Caravaggio even
painted himself into the picture of
Matthew's martyrdom, standing in the
background behind the executioner with
the sword, again resembling his own
sword. It would not have escaped
Caravaggio that Pope Clement had just

had Giordano Bruno ceremoniously burned at the stake for heresy in 1600, a charge which could easily implicate the artist himself for his increasingly unorthodox interpretations of holy traditions. He was already treading dangerous ground in walking the tightrope 'between the sacred and the profane' as was noted later by a certain Cardinal Paravicino writing in 1603 to a Monsignor Paolo Gualdo – a fellow churchman who had admired Caravaggio's work – in a cryptic comment which can be seen as prophetic.

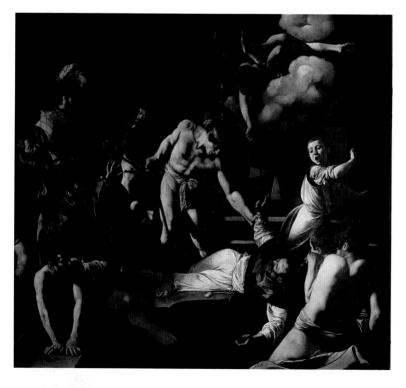

Martyrdom of St Matthew

The scathing and derisive criticism of fellow artist Federico Zuccaro, founder of the painters' Academy of St Luke, who said upon seeing the two Matthew paintings in the Contarelli Chapel, 'I see nothing here but the manner of Giorgione,' deeply rankled Caravaggio's ever-sensitive pride. He must have seen through another's vanity and jealousy for once rather than immediately attacking or challenging Zuccaro to a duel. This time he was secure in his knowledge that for the first time he was more than just on the threshold: for he had now arrived as a successful artist.

Patronage was the key to everything for an artist like Caravaggio. About the time in mid 1600 when Caravaggio finished the first two Contarelli Chapel paintings, Del Monte found him another great commission. A friend of the cardinal, the papal treasurer Monsignor Tiberio Cerasi, who was also a Medici supporter, bought a chapel in the Church of Santa Maria del Popolo. First a lawyer, Cerasi (1544–1601) had achieved the pinnacle of his church career after practising papal law for decades, becoming an ecclesiastic only at the age of fifty. The commission was mediated through the respected banking family of Marchese Vincenzo Giustiniani, the neighbour and great friend of Del Monte who would purchase quite a few Caravaggio canvases for himself and his brother, Cardinal Benedetto Giustiniani, including the earlier *Lute Player*, *Omnia Vincit Amor* (1601–02) and later the first rejected *St Matthew and the Angel* (1602), *Doubting Thomas* (1603), as well as four other Caravaggio paintings between them. The Giustiniani brothers also lived conveniently near in Piazza San Luigi dei Francesi and as music lovers and collectors of antiquities and art often attended Del Monte's concerts around the corner in Palazzo Madama. A new contract was awarded which commissioned Caravaggio for the Cerasi Chapel on 24 September 1600 and stipulated it to be finished in eight months. Perhaps more important to him, Caravaggio's contract was also a legal document that named him for the first time *EGREGIUS IN URBE*

PICTOR: 'Distinguished City Painter of Rome'. Thus it is likely that Del Monte played a role in this artistic and political coup.

The two Cerasi Chapel paintings were *The Crucifixion of St Peter* (1600–01) and *The Conversion of St Paul* (1600–01), the two pre-eminent urban Roman saints. These two paintings were thus far more important to Rome than his Matthew cycle at San Luigi. The portraits were no doubt part of an unspoken competition between Caravaggio and the Bolognese favourite artist of Clement VIII, Annibale Carracci. Carracci had nearly finished the Palazzo Farnese and was politically under the patronage of the Spanish faction of Clement VIII, the Farneses and Aldobrandinis and others, whereas Caravaggio and Del Monte were clearly on the side of the Francophiles, as was Del Monte's Medici duke. This was a duel of Rome's best new artists that was just as political as the machinations of their patrons in Church and State circles. Carracci had the more important vault altarpiece and ceiling frescoes; Caravaggio the lesser side chapel wall space.

Caravaggio's innovative theological vision for both Peter and Paul does not show the Church triumphant at all. Rather it shows the defeat of Rome's patron saint, Peter as an aging man with a tired face being humiliated in a crucifixion upside down by indifferent henchmen. Without a halo or any hint of martyr's crowning splendour or ministering angels waiting in heaven, darkness makes Peter's near-nakedness almost obscene. Saints are thus no more than normal people. They can die ignominious deaths and should not expect rescue from the hordes of angels invisible except to the eyes of faith – to which Peter's rheumy eyes seem blind. Paul's humiliation as the upended Saul is equally a peripety of expectations. There is no glory in either falling off or being thrown by a horse and now being under its hoof. Paul, illuminated,

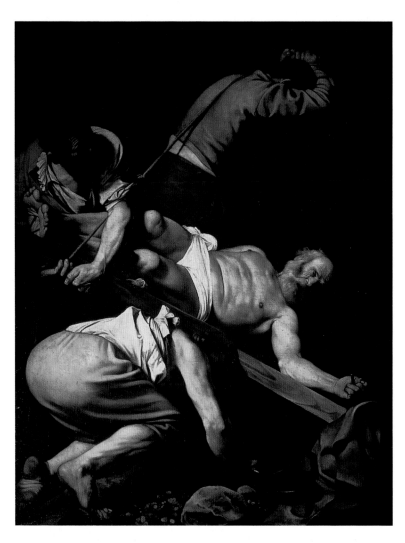

Crucifixion of St Peter

whether the light come from heaven or not, finds his eyelids closed by blindness. In fact, the horse is far more central than the saint. Bellori criticized *The Conversion of St Paul* as a painting where the 'story is entirely without action'. This is because he misunderstood how intellectual and theological drama may be more stunning than pious action; as Spike says, 'Annibale's religiosity is stereotyped and blank.'[24] Ironically, both these versions appear to be the second attempts, since the first versions were deemed unacceptable. Only the first *Conversion of St Paul* (1600–01) has survived, now in the collection of Prince Guido Odescalchi in Rome, but the first *Martyrdom of St Peter* is lost.

What can be said of the expected competition between the two artists? Carracci's *Assumption of the Virgin* clearly went according to contemporary expectation. But Caravaggio's paintings entice the viewer into the canvas space with his controversy and unexpected presentation. Even though he would not have been assumed victorious in the myopia of his contemporary judges or by the gloating Baglione, who said, 'These pictures were first worked by him in another manner, but as they did not please the patron, Cardinal Sannessio took them for himself; and Caravaggio made those which can now be seen.' Cardinal Giacomo Sannessio, Secretary of the Consulta over the papal states, himself a friend of Del Monte, must have been prescient in taste and vision. Caravaggio's ultimate victory in this duel was assured, however dangerous to him its political repercussions later. How he must have exulted in his new title as Distinguished City Painter, whether or not he understood he was then little more than a political pawn between dangerously acrimonious political and ecclesiastic Roman factions.

Another painting that would soon increase his reputation was the equally bold *Supper at Emmaus* (1601), now in the National Gallery in London. Baglione cynically said of it 'Ciriaco Mattei was likewise seduced by the clamour; Caravaggio painted for him . . . *Our Lord When He Went to Emmaus* . . . thus did Caravaggio

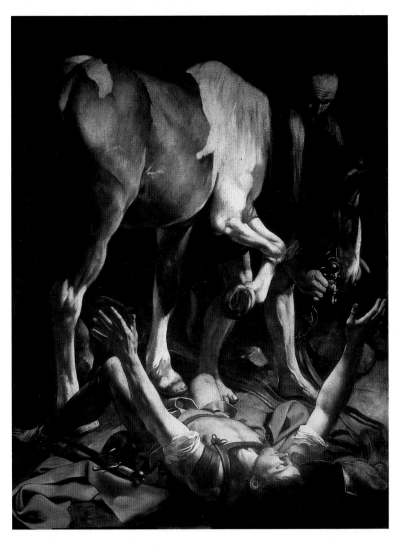

Conversion of St Paul

relieve this gentleman of hundreds of scudi.' Since the Mattei brothers, Ciriaco and his brother Cardinal Girolamo Mattei were generous new patrons of Caravaggio, and since Caravaggio had been living in Palazzo Mattei since some time in 1600, Baglione's jealousy is apparent. Painting the *Supper at Emmaus* marked another milestone in which Caravaggio departs from accepted

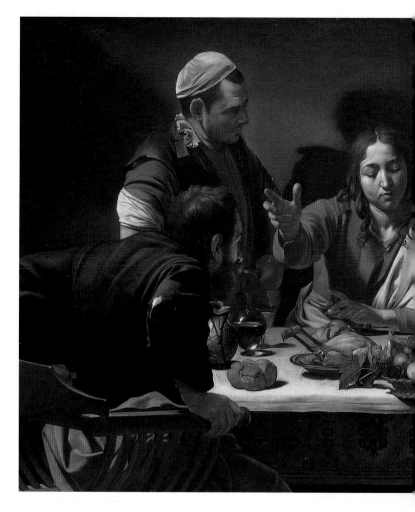

Supper at Emmaus

iconography by painting the resurrected Christ of the Luke 24:13–32 narrative without a beard. This can be attributed to one of at least two possibilities. The first possibility is that he is doggedly aware of scriptural precedent in that according to tradition Christ's beard was plucked out during his Passion with the ill treatment received as a criminal by the supporters of Herodian,

Roman and Sanhedrin policy and their torturers (prophesied in Isaiah 50:6: 'I gave my back to the smiters and my cheeks to them that plucked out the hair'). The second possibility is that Caravaggio is feeding the new academic interests in Palaeo-Christian art as seen in catacombs and fourth-century churches such as at Ravenna where Jesus is beardless both as in the late Classical sculptures of the Good Shepherd and in mosaics of his baptism. In either case, Caravaggio is departing from convention as well as suggesting a most plausible natural reason why the Emmaus disciples would not recognize Christ after his death and resurrection.

Bellori also criticizes this picture: 'In the *Supper at Emmaus*, as well as the rustic character of the two apostles and the portrayal of Christ as young and beardless, the innkeeper is serving with a cap on his head and on the table there is a plate of grapes, figs and pomegranates out of season.' Here Bellori is upset by the 'rustic' apostles who are shown with tears in their garments because they are poor. He also criticizes Christ's beardlessness and the lack of decorum in the innkeeper who wears his hat in the presence of Christ. But Bellori entirely missed the point that nobody recognizes Christ yet, even though the two disciples are just arriving at that moment when Christ broke bread with them and their 'eyes were opened' (Luke 24:31). Furthermore, the out-of-season fruits are probably fulfilling several roles of Christ as the Vine (John 15) and the First-Fruits of Resurrection (I Corinthians 15:20, 23). Bellori may know his traditional artistic formulae but not his scripture, so he argues that Caravaggio 'turns everything upside down' with his abandonment of time-honoured formulaic conventions.

With at least five of his religious paintings rejected by the original commissioners in the short period between 1600 and 1605 (the first *St Matthew and the Angel*, the first *Conversion of St Paul* and *Crucifixion of St Peter* as well as the *Death of the Virgin* in 1602 and the *Palafrenieri Madonna*, 1606), Caravaggio must have been taking great chances and frustrating both himself and these patrons. His startling imagery was increasingly bold and unlike anything seen before in the conventions of Christian art, especially in the Counter-Reformation with its strictures and rigidities of theological interpretation. This no doubt made some viewers uneasy because the paintings lacked the standard piety all other artists followed. Caravaggio was inching further out on a theological limb.

Caravaggio's first *St Matthew and the Angel* (1602) was commissioned because the original planned sculpture by the French Jacob

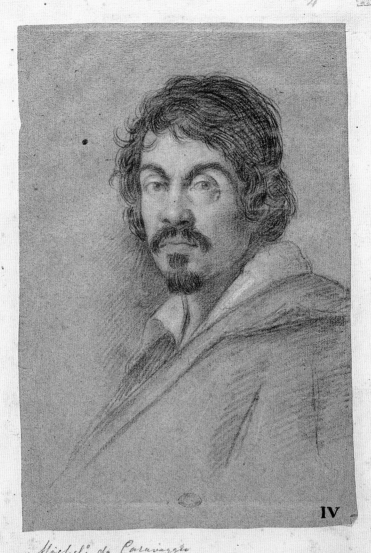

Michel.^o da Caravaggio

Ottavio Leoni's drawing of Caravaggio

Cobaert intended for the altar of the Contarelli Chapel of San Luigi dei Francesi was rejected in favour of the continuity of painting. The painting was considered too sensual with the boyish angel sinuously entwined around the saint; the Church totally misunderstood Caravaggio's likely allusion to divine inspiration and the paradoxical interplay between human and divine in scripture. The second painting of 1602 that was installed permanently removes any problem of proximity: the suspended angel hovers far above Matthew at a decent distance. Heaven and earth

Doubting Thomas

are safe from mixing and Matthew even has a tiny ring of a halo to acknowledge his special role as an inspired gospel writer. These changes must have been concessions to some piety Caravaggio did not personally possess.

Furthermore, Caravaggio's *Doubting Thomas* of 1603 is amazingly realistic for gospel literalism, evidently too graphic for the Church. Thomas's finger probes too deep into Christ's torn side, his peering incredulity not as gross as the flap of skin being stretched by his probing finger. Light dawns on Thomas's furrowed forehead as he finally believes in response to Christ's command: 'Poke your finger here, Thomas' (John 20:27). It is as if Caravaggio is suggesting that belief for the weak of faith is boxed in by sheepish orthodoxy and limited by experiential empiricism, but for those who truly believe without sight (even if misunderstood), greater blessing will follow. A pattern is beginning to appear where Caravaggio is much more faithful to biblical texts than Church traditions. Where does he find these idiosyncratic iconographies? Is he just being iconoclastic or does he invent these variants? On the other hand, is Caravaggio merely literally interpreting narrative texts outside the canon of ecclesiastic-approved exegesis, a more typical Protestant hermeneutic and a behaviour the Church had always frowned upon greatly?

The growing contemporary questions over Caravaggio may have been somewhat stilled by his interpretation of the *Entombment of Christ* (or *Deposition*) of 1602 painted for the Chiesa Nuova of the recently canonized St

Philip Neri (San Filippo Neri) and the Oratorians and commissioned by Girolamo Vittrice, yet another friend of Del Monte and fellow member of the Archconfraternity of the Sacred Trinity of Pilgrims like nearly all other Del Monte friends and patrons to whom Caravaggio had been introduced. Some believe this painting to be his most perfect composition and the closest vision to Classic Renaissance ideals. Despite this adherence to iconographic tradition, Caravaggio still makes a dramatic statement unlike any other, both in the emotive range of the company of mourners and the earthy, craggy face of the saint – possibly the believing Pharisee Nicodemus, as Bellori identified him – who carries Christ's stiffening legs. His bent back is also a counterbalance to Christ's folded body. Many have pointed out the diagonal line of mourners and their various expressions of grief moving down from upper right to lower left as well as the huge tombstone slab under Jesus' body which still carries the weight of the whole group. The aged shock of the Virgin Mary compares to the almost trancelike grief of the Magdalene whose eyes roll back in her head almost out of control and whose hands assault the air. The face of the lower mourner carrying Christ is excluded from the diagonal line of mourners and is the most intimate detail of the painting, his confrontational gaze seemingly intended to draw the viewer into the poignant moment of burial so that one experiences the numbing grief of this man. Bellori, usually highly critical, regarded this as Caravaggio's best: 'The *Deposition of Christ* in the

'Caravaggio is one of the few Italian painters who seemingly never used drawings. X-rays prove he repainted canvases, sometimes abandoning one subject for another, often substituting one detail for another, even altering a whole composition. The conclusion from available evidence [including incision lines where models were repositioned in different sittings] is that he must have painted directly onto canvases, but so sure was his judgment that he rarely made changes to his original ideas.' (Timothy Wilson-Smith, *Caravaggio*)

Chiesa Nuova is deservedly regarded as being among the best works of Michele's brush . . . all the nude parts are portrayed with the force of the most precise imitation.'

Two additional paintings show Caravaggio's preference for natural rather than supernatural details and his reduction of the miraculous to the mundane: *The Madonna of Loreto* and the *Death of the Virgin*. He seems to have journeyed from Rome around 1603 to Tolentino on the Adriatic coast and also stopped to make a special pilgrimage northeast at Loreto where the popular shrine of the Virgin included what was purported to be Mary's original Nazareth house. Supposedly miraculously transported from the Holy Land in the thirteenth century, this small brick house, the Santa Casa, now stood as a relic dwarfed inside the domed cathedral shrine that Sangallo and Bramante had built and decorated along with frescoes by Lorenzo Lotto, himself a pilgrim and lay brother there until his death in 1557. Cardinal Baronio, revisionist father of Palaeo-Christian archaeology seeking to authenticate early church artifacts, had mostly approved the Casa Santa as indeed the genuine house of Mary in Nazareth with full church blessing, but although Caravaggio may not have been convinced of this, he was still seemingly touched by something at Loreto. Pilgrims flocked to Loreto by the thousands from all over Italy and the Catholic world for cures of ailments and protection against mortal wounds or cures for infertility. The desperation of these pilgrims – so many sick, palsied, maimed, crippled and poverty-stricken – must have moved Caravaggio, who soon responded to the request of the heirs of Ermete Cavelleti, whose chapel in the Church of Sant'Agostino in Rome needed an altarpiece. Caravaggio was commissioned in 1603 to paint it. Although it is often suggested that the striking model for Mary in *The Madonna of Loreto* was none other than 'Caravaggio's girl, Lena', Maddalena Antonietti, even a young prostitute and a chubby baby as Jesus cannot compete with the true subjects of the

picture. The kneeling poor couple with their pilgrim walking sticks look like they have stepped right off a Loreto street. Unpretentious and devout, they are true believers. With dirt stains on weathered clothes and bare feet, their humble faces look up to Mary above praying hands. Stucco is falling off next to the doorway, exposing brick underneath. Nothing could be more simple and realistic. Even Mary has bare feet, which offended some critics who weren't at all happy with so many bare dirty feet in the picture. Humility wasn't apparently as becoming as Christ

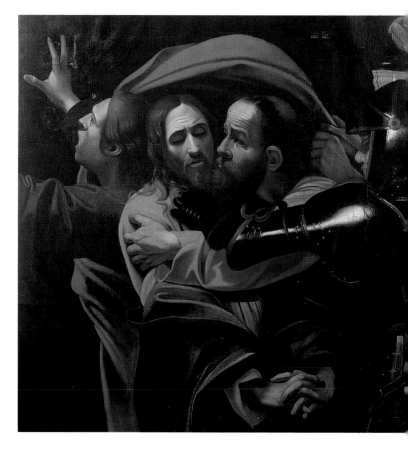

Taking of Christ

himself had modelled it. Bellori's criticism is clear: 'Two pilgrims with clasped hands are standing before her, the first of whom is a poor man with bare feet and legs.' Evidently 'poor' and 'bare' are unseemly. A grudging Baglione is even more telling: 'a Madonna of Loreto portrayed from life, with two pilgrims, one of them with muddy feet, and the other wearing a torn and soiled bonnet, and because of these frivolities in the details which a great picture must have, the populace made a great fuss over it.' Again the similar word choices of 'muddy', 'torn', 'soiled' – but even a jealous

Baglione concedes it is a great picture despite his denigration of such 'frivolities' by stating it was 'portrayed from life', and he has to admit it was greatly popular with the masses, no doubt because they saw themselves in it instead of the usual powerful prelates and rich nobles.

His *Taking of Christ* in 1602 is not so revolutionarily offensive but the emotion of a fleeing disciple – probably John – is offset by the despairing sorrow of abandonment and betrayal on Christ's face as Judas falsely kisses him. Only Christ's face is offered fully to the viewer; all the others are in profile, including the probable face of Caravaggio himself as a curious spectator behind the implacable arresting soldiers. It has been noted by Spike and others that Caravaggio carries a lantern, like Diogenes searching for an honest man. Christ's hands are still folded at the bottom below the soldiers'

shining black armour as if he was interrupted in prayer in the garden as in Matthew 26:44. This was a painting for Ciriaco Mattei while Caravaggio was living in the Palazzo Mattei along with Ciriaco and his brother for a period of about two years between 1600 and 1602. This palazzo on the Via dei Funari was built by Carlo Moderno for Asdrubal Mattei from 1598 onwards behind what would become the Piazza Mattei during Caravaggio's residence there. Another Mattei residence, the nearby Villa Mattei, built around 1582 (now Villa Caelimontana), had assimilated part of the old Roman Domus Augustana and was adorned by an Egyptian obelisk given to Ciriaco Mattei by the Roman senate.

If the *Madonna of Loreto* was offensive to some, Caravaggio really scandalized many, especially in the Church, with his *Death of the Virgin*. It was almost as if he refused to compromise his position regardless of how much controversy it would bring. Commissioned earlier in 1601 by Laerzio Cherubini, a prominent judge and friend of Vincenzo Giustiniani in Del Monte's circle, the painting was designated for the Carmelites of the Santa Maria della Scala in Trastevere. Caravaggio totally changed the usual iconography of a triumphant Mary surrounded by the Apostles about to ascend to heaven with Jesus and a joyous host of angels pulling the sky back to heaven. Instead, Caravaggio has the ageing apostles gathered around, having journeyed far from apostolic missions all over the world, in front of a very dead and altogether human Mary. Her arm is inert and lifeless and her blank face is anything but beatific. Her lifeless uncovered feet stick out from under the blanket at the foot of the bed, definitely those of a corpse. Abject apostles are mourning with mouths agape and forlorn bent heads as the loss strikes deeply home. The pious believers in Marian elevation (of whom Caravaggio seems not one here) could ask where is the hope of Resurrection and veneration of the most important woman in the world?

Thus Caravaggio rejected centuries of hagiography and made

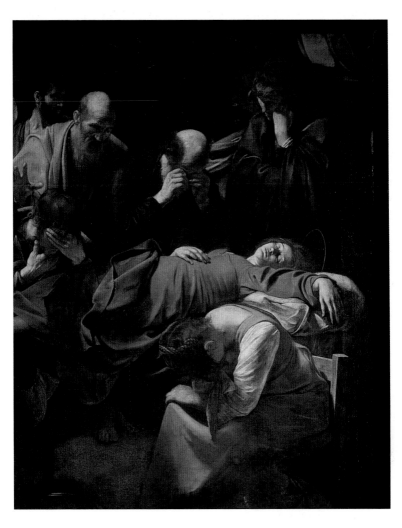

Death of the Virgin (detail)

realism his goal instead. The uproar over what was perceived as ugly and tarnished still echoes from the many critics then and recently. Both Bellori and Baglione were without restraint in their criticism and even Mancini finds fault or at least tries to pinpoint the cause for why it was rejected by the Carmelites. Baglione says, 'Because he portrayed the Madonna with little decorum, swollen and with bare legs, it was taken away.' Bellori likewise says 'Owing to his pursuit of this style [realism], his pictures were taken down from their altars . . . The same thing happened to his *Death of the Virgin* in the Chiesa della Scala, removed because he had imitated the dead body of a woman too closely.' The usually praiseful Mancini is more explicit and pietistic: 'wishing to portray the Virgin Our Lady, depict some dirty prostitute from the Ortacchio, as Michelangelo da Caravaggio did in the *Death of the Virgin* in that painting for the Madonna della Scala, which for that very reason the good fathers rejected and perhaps that poor man suffered so much trouble in his lifetime.'

The charges are clear: 'dirty', 'dead' 'prostitute' and 'imitated . . . too closely' with realism to the extreme. The model for the dead Mary seems to have been fairly well known to the community if Mancini was able to identify her lifestyle, the so-called legend of the woman drowned in the Tiber as Bonsanti relates.[25] Others like Robb suggest the model for Mary was 'Lena' (Maddalena Antonietti),[26] which would fit the chronology, but it is more important that this use of a known courtesan confronted Cardinal Paleotti's potent injunction against profaning holy art with unholy *meretrici*. Even with protection from cardinals there must have been growing whispers of blasphemy. It is no wonder the outrage and controversy over Caravaggio's art were growing even while his commissions and fame were piling up. Bellori had related rather more in criticism that Caravaggio thought 'Nature was the only subject fit for his brush.' This comment reflects Caravaggio's unwavering commitment to what he saw in nature

over convention and iconography even during the stranglehold of the Post-Tridentine strictures on what artists could depict and how they might render fit religious subjects. Evidently the world was not yet ready for Caravaggio's realism of the most exacting depiction and fidelity. There needed to be a place for faith, but the only kind to be found in Caravaggio was the humble, unadorned faith of the poor and simple.

Libel, Prison and Escalating Violence 1603–1605

It would seem that even his longsuffering patrons could not keep Caravaggio out of prison, even if they could mitigate his time behind bars and possibly prevent further civil punishments during this period between 1603 and 1605. Never was he more able to pick and choose commissions, although one could not easily refuse a request for a papal portrait, as came in 1605. Between 1603 and his disastrous crime in 1606, Caravaggio was his own worst enemy in public. The events of the years of 1603–05 demonstrate his inability or indifference in managing his social and professional obligations. If it were not for his patrons, worse things would have happened to such an artist, who refused to conform, perhaps because of his high standards in art and his antisocial behaviour. In mid 1603 Caravaggio was commissioned to paint the *Sacrifice of Isaac* by Maffeo Barberini another one of Del Monte's likely connections. Barberini would later become Pope Urban VIII in 1623.

Caravaggio's next brush with the law, and subsequent arrest, was on 11 September 1603. The extenuating circumstances are easily reconstructed, owing to the surviving court records. Furious in the late summer over damaging libel and impugning of his artistic merit, Baglione sought legal redress in late August. His lawsuit for libel convened on 11 September. Baglione contended that Caravaggio had undermined his artistic merit out of jealousy. Some claim that Caravaggio accused Baglione of imitating his style both in doggerel verse and in public. The feud had been simmering all year over commissions and preferential patronage, for not every substantial commission of Del Monte's circle went Caravaggio's way. Cardinal Benedetto Giustiniani had

commissioned Baglione to paint a *Divine Love Subduing Profane Love* and the generous cardinal had given Baglione a gold chain in return. Caravaggio would have known this, partially because it would have been paraded by Baglione. Baglione had also painted a *Resurrection* for the Il Gesù, the important Jesuit church in Rome; this may have rankled Caravaggio somewhat, Baglione claimed that Caravaggio had wanted this commission. This was probably unfair; as Spike points out, Caravaggio was not someone who would ever work for the Jesuits[27] and no doubt this claim brought the simmering feud to a boil. Nasty public insults were now traded back and forth between the two artists and their circle of friends.

The libel evidence was considered circumstantial but sufficiently damaging. Tommaso (Mao) Salini testified that Caravaggio authored these verses in private, since no name was attached as author. Then Caravaggio's old friend and Ortacchio district rabble-rouser, Onorio Longhi, was also accused of circulating these verses. If Caravaggio was found guilty by the court, His punishment would be a dangerous consignment to rowing in the papal galleys in the waters of the western Mediterranean and up and down the coast. Such a legal prisoner would be close to a slave and subjected to more than just humiliation. Galley conditions were horrific and almost always life-threatening.

The court records several depositions in which Caravaggio's words were taken down. Their subject matter constitutes just about the only art philosophy and aesthetics of Caravaggio in print, ironically unpublished by the art community but instead by the legal court where he was the accused. Other defendants included in Baglione's lawsuit were Caravaggio's erstwhile artist friends Orazio Gentileschi, Ottavio Leoni (who drew the only surviving portrait of Caravaggio), and Filippo Trisegni, but their participation was considered secondary and accessory to

Caravaggio's as author of the verses. It was certainly no coincidence that Tommaso Salini, star witness for Baglione, had been assaulted by Caravaggio in 1601. Allegedly, the verses in question were addressed to Filippo Trisegni. Caravaggio testified on 13 September that he had no knowledge of the poems and denied having anything to do at that time with any others mentioned, including a certain Giovan Battista whom Salini called Caravaggio's *bardassa* (male concubine or low life companion). Here are Caravaggio's own words: *I was seized the other day in Piazza Navona. I do not know why. I am a painter. I think I know nearly all the painters in Rome, and beginning with the good artists, I know Giuseppe {Cesari}, {Annibale} Carracci, {Federico} Zuccaro, Pomerancio {Roncalli}, {Orazio} Gentileschi, Prospero {Orsi}, Giovanni Andrea {Galli}, Giovanni Baglione, Gismondo and Giorgio the German, {Antonio} Tempesta and others. Nearly all the painters I have mentioned above are my friends but not all of them are good painters. By a good man I mean someone who can perform well in his art, and by a good painter a man who can paint well and imitate natural things well. Among those I have mentioned above neither Giuseppe, nor Giovanni Baglione, nor Gentileschi, nor Giorgio the German are my friends, because they do not speak to me; all the others speak to me and converse with me. Among the painters I have mentioned above, I consider as good painters Giuseppe, Zuccaro, Pomerancio and Annibale Carracci; I do not consider the others good artists.*

Caravaggio claimed that he did not know why he was arrested. He appears to suggest that as a painter, he has no reason to be here, that this is a matter of aesthetics, not law. It is significant that he mentions all the painters by either first name or surname but with Baglione he uses the full name 'Giovanni Baglione'. This distinction appears almost too careful to be casual. He clearly distinguishes both good artists and friends; the former imitate nature and the latter speak with him. He is also outspoken in his opinion that Baglione does not belong in his category of good

artist but he makes the point only indirectly by contrasting those by name he considers as good and lumping the others without mentioning names.

Caravaggio continues: *Good artists are those who understand painting, and they will judge good painters those I have judged good, but bad and ignorant painters will judge good those painters who are ignorant like themselves. I do not know that any painter praises and regards as a good painter any of those I do not regard as good. I forgot to say that Antonio Tempesta is a good artist too.*

Here Caravaggio uses the old rhetorical bandwagon argument: agreeing with him would show they were good men (*valentuomini*) and who could possibly disagree with him unless they were bad artists? Mentioning Tempesta is his insurance as a friend and therefore a 'good' artist probably disliked by the 'bad' artists like Baglione and Salini. Having warmed up, he continues now very pointedly and without much caution: *I know no painter who praises Giovanni Baglione as a good painter. I have seen nearly all the works by Giovanni Baglione; namely the high altar in the Madonna dell'Orto, a picture in San Giovanni Laterani and lately, Christ's resurrection at the Gesù. I do not like this painting because it is clumsy and I regard it as the worst he has ever done and I have not heard the painting praised by any painter. Of all the painters with whom I have spoken, none like it except one who is always with him, and who is called his guardian angel; he was there praising it when it was unveiled and they call him Mao. When I saw it Prospero {Orsi} and Giovanni Andrea were with me, and I have seen it other times when I have had occasion to go the Gesù.*

Caravaggio now made no attempt to hide his contempt for Baglione as an artist and for the specific painting, again using the bandwagon argument (*I know no painter who praises Giovanni Baglione*). He could hardly be more insulting than calling the painting *clumsy* and Baglione's *worst*. Caravaggio upended the neutrality of his defence testimony by implicating Tommaso Salini as a toady (whom he already knew from the 1601 assault)

who was not much of a painter. He underscores that he has seen Baglione's painting in question multiple times with other artist friends, hence he is trying to cast his as neither a solo or unfamiliar opinion. Caravaggio continues: *I know Onorio Longhi who is a great friend of mine and I also know Ottavio Padovan {Leoni} but I have never spoken to him. With the former I have never spoken about Baglione's resurrection and Gentileschi has not spoken to me for over three years.* Caravaggio may have intended to imply that Longhi was both a friend because he was a good artist and a fellow defendant, naturally another good artist maligned by bad artists. Caravaggio was probably lying about Gentileschi from whom he had borrowed some wings and possibly a Capuchin friar's habit as studio props and to whom he had returned them just ten days before the trial. Gentileschi's testimony the following day (14 September) contradicted Caravaggio's testimony by saying they hadn't spoken for about eight months and mentions the returned borrowed 'wings'. Caravaggio mentioned his old friend and roommate Mario Minniti whom he last saw three years previously and Bartolomeo who was a former servant of his. Baglione, and Salini as his witness, had implicated Gentileschi, Minniti, Giovan Battista (the putative *bardassa* of both Caravaggio and Longhi) and Bartolomeo as part of the plot and Caravaggio was trying again to distance himself from all these other co-defendants. The final statements by Caravaggio ring somewhat untrue as a lie by omission or by outright denial: *No sir, I do not amuse myself composing verses, whether in Latin or Italian.* This is not an absolute denial of having written the verses, only that he doesn't amuse himself by composing them. Furthermore, his last words seem just as false to modern ears and eyes as to the court: *I have never heard of the existence of rhymes or prose against Baglione.* The court found this implausible since Salini and Baglione had charged Onorio Longhi with possessing them. Onorio Longhi was a well-educated, gifted architect and artist, son of the even more famous deceased Roman architect

Martino Longhi. But Longhi himself was contentious, brash, given to obscene bellicosity and in jail just about as often as Caravaggio. Since Longhi was Caravaggio's best friend, it was absurd to deny knowing about them. Thus Caravaggio had doubly incriminated himself with both Longhi and Gentileschi as guilty by association. Perhaps Baglione knew he could get Caravaggio to defame him publicly in a court of law and thus the alleged verses were just a cause on which to bring Caravaggio et al to court. He did himself no favour here. He could not bring himself to save his neck and avoid a jail sentence by resisting an opportunity to publicly defame Baglione. As Baglione no doubt hoped, the court made little distinction between defamation and libel. Caravaggio went to jail in Tor di Nona Prison for two weeks in September (during the trial from 12 to 14 September) with ten more days of incarceration until around 25 September.

Just north of the Piazza Navona, the Tor di Nona Prison was a horrible place even by seventeenth-century standards. On the east bank of the Tiber river, it was as dank and awful as a crumbling medieval fortress could be, already centuries old. It was once part of the Roman Orsini family fortifications overlooking the old Tiber ferry crossing just upstream of the current Ponte Umberto. Often subject to flooding it was rife with disease, including cholera and tuberculosis, as were all prisons. Many prisoners in the lower cells had perished during flooding in 1495 when the Tiber overflowed its banks. Before Caravaggio arrived, a previous artist, the famous and infamous Benvenuto Cellini had been imprisoned there. Additionally, it would not have been lost on Caravaggio that the 'heretic' Giordano Bruno had been imprisoned there prior to his execution in 1600, only a few years previously. Caravaggio would come to know Tor di Nona too well in the following years.

Fortunately for Caravaggio, he was released early in his sentence through the intervention of the French papal ambassador in Rome, Philippe de Béthune, Comte de Selles. Béthune's action

was possibly instigated by Del Monte and the Tuscan Medici and French faction since Grand Duke Ferdinand de'Medici's sister, Catherine was Queen of France. How long Caravaggio would have stayed otherwise before being sent to the papal galleys is inestimable. Caravaggio was, however, still under house arrest. If he left his house without securing magistracy permission, he would face arrest and the galleys. Additionally, Caravaggio was made to promise no harm or further insult to Baglione and Salini. This promise was 'underwritten' and secured by a guarantee in writing from a Tuscan Knight Commander of Malta, Fra Ainolfo Bardi, to the governor of Rome, Monsignor Ferrante Taverna. Béthune apparently profited from his mediation for Caravaggio; his 1608 inventory showed he owned four paintings by Caravaggio.

After his release from Tor di Nona Prison in late September, 1603, Caravaggio rented rooms from a wealthy and respectable widow in Rome, Madama Prudenzia Bruni. Whether this was because his noted patrons were unwilling to risk themselves any further, or because he wanted more independence, Caravaggio could certainly afford his own quarters. This new residence was not too far away from his familiar landscape of the Palazzi Madama, Giustiniani and Mattei: his rented quarters were in the Campo Marzio *rione* near the Palazzo Firenze, a short distance to the north. He immediately began painting again with a fury, partly because he was under house arrest and partly because he was inundated with commissions. He stayed out of trouble for a few months even when Onorio Longhi was arrested in November 1603 for continuing to insult and attack Baglione and Salini.

But trouble soon found Caravaggio again. In April 1604 he was fined because he had thrown boiling *carciofi* (artichokes) at a waiter in the Albergo del Moro, nearly blinding him, threatening also to skewer the waiter with his sword. He had been insulted when the waiter had not given him his due as a gentleman. Just a few months later, in October, he was back in jail in Tor di Nona

because of a civil misdemeanour while walking home from dinner at a place called Osteria della Torretta. Possibly drunk, and walking with several friends, he suddenly threw paving stones at someone or something, possibly doing either property damage or bodily injury. He asked one of his companions, a bookseller, to notify Cardinal Del Monte, evidently still able to seek help from this powerful patron. Only one month later, in November 1604, Caravaggio was in Tor di Nona, this time for insulting a *sbirro* officer who had rightly asked to see his permit for sword-carrying, probably adding the charge of belligerence in resisting arrest. On 28 May 1605 he was back once more at Tor di Nona for wearing his famous sword without a permit and perhaps this time his sword and dagger were confiscated. Yet again, in July 1605, he was imprisoned for defamation and insult to a whole family, particularly a Roman matron Laura and her daughter Isabella, possibly for calling one or both of them *meretrici* in verse or song (which may positively reinforce our interpretation of Baglione's suit against Caravaggio as author of the obscene verses). In the same month, the Mariano Pasqualini affair also took place in the Piazza Navona, when Caravaggio wounded the notary from behind with his sword, over the above-mentioned Maddalena Antonietti. Escaping to find only a temporary hiding place in Palazzo Madama with Del Monte, Caravaggio knew this time it could be interpreted as attempted murder by the court, easily punishable by hanging. Caravaggio fled in haste to Genoa, returning only after paying a huge settlement to the notary. Finally, Caravaggio was arrested again in September 1605 for throwing stones through the upper windows of the home of Prudenzia Bruni and breaking the Venetian blinds. This was no doubt over a disagreement concerning back rent for which she had taken him to court (and also sequestered his belongings as her inventory noted when he fled to Genoa).

The frequency and severity of Caravaggio's legal scrapes were

Inventory of Caravaggio's possessions: from his house in Vicolo di San Biagio, Rome, 26 August 1605 when his former landlady Prudenzia Bruni sequestered his belonging for six months' back rent after he fled to Genoa.

1 water jug	1 bed with two posts
2 stools	1 chamber pot
1 red table with two drawers	1 stool and old chest
2 bedside tables	1 majolica basin
1 picture	1 other chest containing 12 books
1 small coffer in black leather, containing a pair of ragged breeches and a jacket	2 large pictures to paint
	1 chest containing certain rags
	3 more stools
1 guitar	1 large mirror
1 violin	1 convex mirror
1 dagger, a pair of earrings, a worn-out belt, a door leaf	3 smaller pictures
	1 small three-legged table
1 large table	3 large stretchers
2 old straw chairs and an old broom	1 large picture on wood
2 swords	1 ebony chest containing a knife
2 hand daggers	2 bedside tables
1 pair of green breeches	1 small wooden tripod
1 mattress and a blanket	1 small cart with papers of colours
1 shield	1 halberd
1 foldaway servant's bed	2 more stretchers

increasing. This may not be surprising given Caravaggio's mercurial temper and pride. However, the temporary self-poisoning of artists from the grinding and mixing of painting concoctions would no doubt also affect an artist's disposition. Aligned with frequent drinking in taverns and association with equally volatile and possibly violent companions (Joichim von Sandrart said in 1675 this group had as their motto *nec spe, nec metu*, 'without hope, without fear'), Caravaggio's outbursts are increasingly sad considering his acclaimed genius by 1605.

Caravaggio's first known *David and Goliath* (now in the Prado, Madrid) was seemingly painted in 1605 based on the age of the

youthful Francesco 'Cecco' Bonero (also in *Victorious Cupid*, 1602, *St John the Baptist-Isaac*, 1602, and *Sacrifice of Isaac*, 1603, among others) here modelled as David. Finding this a subject he repeated many times for no apparent reason other than possible identification with both violent giants and their young nemeses (curiously like the role of Ranuccio Tomassoni), Caravaggio has made Goliath an apparent self-portrait for decapitation, unwittingly prophetic of the potential punishment as a fugitive homicide the following year. Some suggest the younger and the older Caravaggio as David and Goliath for a bewildering psychological contrast. Decapitation would haunt Caravaggio in any case through the next decade of painting in a life ever grimmer and more insecure.

From this same period of arrests and imprisonments also comes the rare autograph document attesting Caravaggio's contract with Massimo Massimi on 25 June 1605. Massimi was a courtier who lived in the famous Palazzo Massimo Colonna, rebuilt for the three Massimo brothers (Pietro, Luca and Angelo) in 1532–36 to designs by Baldassare Peruzzi with a façade of old Roman columns from before the Sack of Rome. Massimo was a papal government officer and had inherited the palace. He had already commissioned Caravaggio for a *Crowning with Thorns* and this new commission was for an *Ecce Homo* painting in this time period. The contract, now in the Palazzo Massimo Archives, reads: *I Michel Angelo Merisi da Caravaggio undertake to paint for the Most Illustrious Signor Massimo Massimi, having been paid in advance, a painting of the same value and size as the one I have already made of Christ's Crowning, by the first of August 1605. I attest I have written and signed this below in my own handwriting on this the 25 June 1605. I Michel Angelo Merisi.* It is still uncertain if Caravaggio actually ever finished this painting for Massimi because of his flight from Rome to Genoa during the Pasqualini debacle.

Three unfortunate related encounters with competing artists

over a short time span are relevant. Caravaggio challenged the younger artist Guido Reni to a duel in 1605 because he felt the former was copying his style, a substantive accusation in his eyes or others' (*a theft of my palette and method*). In reality, his pride was hurt because Cardinal Aldobrandini had chosen Reni to finish a St Peter's-Basilica commissioned painting on St Peter's crucifixion. In 1605 another Tuscan artist known as Passignano but whose real name was Domenico Cresti had been awarded a St Peter's Basilica commission of St Peter's crucifixion. As a result of jealousy, Caravaggio thoroughly demolished Cresti's working tent inside St Peter's, slashing it irreparably with his sword. Then, although Giuseppe Cesari had been knighted as Cavaliere d'Arpino by Clement VIII back in 1600 in gratitude for his frescoes for the Church of St John Lateran, it rankled Caravaggio that Cesari went to court on a horse befitting his station. Sometime between 1603 and 1605, Caravaggio may have been forced to step aside in a narrow street due to Cesari's mounted passage on a fine horse en route to the papal court to see Clement or one of his assistants. Because he nearly always carried his sword, Caravaggio shouted, *Since we're both armed, let's settle this matter with a duel.* His former employer, Cesari the Cavaliere d'Arpino, archly replied he wouldn't defile himself with someone beneath him like Caravaggio, a man of inferior social standing. This would perhaps have wounded Caravaggio more than anything else he had suffered and at least one of his early biographers in 1675, Joichim von Sandrart, felt this unfortunate encounter between competing artists pushed Caravaggio over the edge in enraged humiliation.

On the night of 24 October 1605, Caravaggio was found lying in the street by *shirri*. He was bleeding, wounded in the throat and left ear, punctured either by sword or dagger and would not admit to having been involved in a swordfight. He swore he had fallen on his own sword and he was taken nearby to the house of Andrea Ruffetti, a lawyer friend, where he recovered. He was

forced to pay a fine of 500 scudi, a huge sum for an artist. His laconic and possibly mocking defence before the magistrate was: *I cut myself {on the throat and the left ear} with my own sword. I fell down on the street. I don't remember where and there wasn't anybody around.* Some plausibility from his record of tavern rowdiness might have suggested to the police he was inebriated and this may have been warily accepted as an extenuating circumstance, thus only the huge fine. His assailant or assailants remained anonymous. As always before, someone must have been protecting him, possibly Del Monte and even others including the Borgheses. There is some suggestion that Caravaggio's finances were straitened during 1605, and this fine would have been a considerable setback to his wealth. He may even have had to borrow money until new commissions came in. But this life-threatening injury that had left him lying bloody in the street was a scary prelude to the worst event to follow in Caravaggio's short life and should have been a severe warning.

What happened on 28 May 1606 changed completely the course of Caravaggio's career and life. Although tensions had been building for years, the dam broke with a fight that left Caravaggio running for his life. The fight on this night started on a tennis court, over a bet or match that turned nasty. The whole environment of Rome was tense at this time, for the international political factions were constantly fighting on diplomatic fronts over papal turf. This often spilled over into the neighbourhood turf with an alarming result that left Caravaggio the object of a hue and cry. Who was to blame? Circumstances were not in Caravaggio's favour that evening.

Ranuccio Tomassoni was a young armed Campo Marzio neighbourhood enforcer. Baglione described him as 'well-mannered'. His Roman family, originally from Terni, was noted for its control of the Campo Marzio *rione*, his retired soldier brothers dividing up the duties of protection and corruption. His father Lucantonio Tomassoni and other family members had served in the papal armies; Lucantonio had fought decades before against the French. His brother Giovan Francesco was the *caporione* or head of the district's unofficial militia-like *bravi* who ostensibly maintained the peace by patrolling to keep other rival gangs out of their turf, an original Roman *West Side Story*. However, the Tomassoni were named in local courts more than any others for brawling in Rome,[28] a troublesome match for Caravaggio's own hot-blooded companions. More importantly, they were aligned with the Farnese and Aldobrandini faction, which were Spanish-leaning. Ranuccio had even been armed in the service of Cardinal Cinzio Passeri Aldobrandini, nephew of Pope Clement VIII.

Political turmoil in 1605 broke out in the city following the death of first Clement VIII and then the elderly transitional pope Leo XI (Alessandro de' Medici) who died after only three weeks in office in April. A quick election saw Camillo Borghese become Paul V on 16 May 1605. Paul V was equally swift to take charge of unruly Rome. Not long thereafter, a summons must have come to Caravaggio for a papal portrait session, which would have been a pinnacle to his career. The invitation was perhaps also meant as partial compensation for Caravaggio's many unsuccessful St Peter's Basilica attempts including the *Palafrenieri Madonna* which had been rejected, bought instead by Scipione Borghese (1576–1633). As a result of this invitation, Caravaggio seemingly painted Paul's portrait in a less dramatic style (now in the Galleria Borghese, Rome) leading some to question about its attribution. The new pope's nephew, Scipione was a canny and even rapacious collector of art, possessing many of Caravaggio's paintings. He went so far as to seize the studio collection of paintings owned by Cavaliere d'Arpino in 1605. The reason for seizure was tenuous: d'Arpino (Giuseppe Cesari) represented Clement VIII and was unofficially out of favour with the Borghese. Unfortunately, the Francophiles among the courtiers, including Del Monte, were not at the centre of power in 1606 and were certainly not favourites of the Tomassoni family. Along with an armed protection service to Farneses and Aldobrandinis, Ranuccio had even been somehow involved at times as a procurer of noble clients for Fillide Melandroni, by now a *cortigiana* way above Caravaggio's station even though he too had risen to far greater heights than when he first painted her.

No doubt the Tomassoni clan was on the watch for rival gangs; Caravaggio and his group were known to be under the patronage of the Medici-French faction and thus were likely competitors in the conflict that unfolded. Varriano states the unfortunate fight and slaying of Ranuccio was as much due to

political tension as anything else.[29] Other fatal brawls had already taken place the same day between Spanish and French papal contingents. Additionally, it wasn't easy for Caravaggio to pass through this district without some kind of trouble. Caravaggio had rented a whole house of several stories in the Campo Marzio on the other side of the Palazzo Firenze in the Vicolo di San Biagio. Reconstruction of the event suggests that Caravaggio, who loved tennis, had lost to Ranuccio Tomassoni, now about 26 years old and nearly a decade younger than Caravaggio, previously in a court on or adjacent to the Via della Pallacorda. At some point, perhaps at the conclusion of the match, Ranuccio and his group of thugs ran out armed and challenged Caravaggio's group. The Tomassoni house was nearby on the Via della Scrofa in San Lorenzo in Lucina parish. Ranuccio started the fight with Caravaggio, continuing a quarrel that was already simmering. Naturally, swords came out and the fight escalated in the street.

On the Tomassoni side was also brother Giovan Francesco, a seasoned swordsman and able soldier; another Tomassoni brother, Alessandro, was also present, he joined the fight, hurrying from the Tomassoni house fairly quickly after it started. Caravaggio was assisted by a soldier friend Captain Petronio Toppa from Bologna, part of the papal guard at Castel Sant'Angelo. Toppa apparently expecting a fight was possibly even brought by Caravaggio for that contingency. Toppa is thought to have fought with Giovan Francesco. Others must have been involved as well. Mancini involves Onorio Longhi, which would have been likely given that he was a frequent companion of Caravaggio and that he had already fought with the Tomassonis the previous year. Others suggest the Sicilian Mario Minniti was fighting with Caravaggio.[30] Thus there would have been at least six to ten men duelling with swords. But Ranuccio was the first to attack.

Ranuccio was struck down, either by Caravaggio alone or with

the help of Longhi and Caravaggio together. Caravaggio, who was himself wounded in the head, struck Ranuccio severely on his inner leg – possibly while he was down – apparently severing the artery behind the thigh or knee or even puncturing his stomach and these arteries. Caravaggio probably targeted Ranuccio's groin. The wound caused Ranuccio to begin bleeding heavily. Longhi and Caravaggio fled, possibly leaving a severely wounded Toppa lying there. Toppa seems to have made it the short distance to a nearby surgeon's where he was later arrested. This also suggests that Onorio Longhi's first beaten combatant had either also fled or gone for help. Giovan Francesco Tomassoni must not have pursued the bleeding Caravaggio and Longhi because he was tending to his dying brother. It is possible that Giovan Francesco carried his dying brother back to their house on that street where he died. Baglione says that 'after Caravaggio wounded him in the thigh, Ranuccio fell down, and he killed him as he lay on the ground.' Whether or not Caravaggio had intended to kill Ranuccio Tomassoni is immaterial: it was a capital offence and could only be interpreted as murder. Someone as notorious for street fighting as Caravaggio would be likely to swing from the gallows for such an attack if apprehended by the authorities.

> 'The painter M has left Rome badly wounded, having on Sunday killed another who provoked him to a fight. I'm told he's heading for Florence and maybe he'll come to Modena as well, so he can make them happy doing as many paintings as they want.'
>
> Fabio Massetti, Tuscan Ambassador to the Duke in Modena, May 1606 (Robb, 340).

Bellori adds: 'The young man was killed and Caravaggio himself wounded.' The *avviso* announcing the crime was fairly clear: 'the painter was wounded and Captain Petronio came to his aid. Ranuccio's brother also, a captain, was on the other side with several more friends, so that as many as a dozen took part. Finally Tommasoni lost his balance and fell over, a sword thrust leaving him dead on the ground.'

Caravaggio fled Rome even while he was sought by the authorities, possibly at first to Del Monte's nearby palazzo or to the Palazzo Giustiniani. It is certain that he had help in escaping through Rome's gates and walls. Because he was from Lombardy and had many Tuscan friends like Del Monte, he was sought first northward. Yet Bellori says 'Caravaggio fled Rome, without money and being pursued, he took refuge in Zagarola with Duke Marzio Colonna' south of Rome. Baglione offers a different version: 'Everyone fled Rome and Michelangelo went to Palestrina,' also south. Yet another contemporary witness, Fabio Masetti, places the fugitive Caravaggio's place of refuge as Paliano, south in the Alban Hills. All three of these were fiefdoms of the Colonna family, who would so often in the next four years offer protection to Caravaggio, thus it is likely that he remained to recuperate throughout the summer months until the heat of the chase died down somewhat and his wounds allowed easier travel. During his recuperation, Caravaggio painted at least a few paintings, including his naked *Mary Magdalene* and also his second *Supper at Emmaus*, which were, according to Bellori, given to the Colonna family as remuneration. Finally, Caravaggio arrived in Naples as a fugitive in October but not without both protection and new commissions. His hasty departure and necessary exile from Rome would have meant lost materials and property. Little did he know then that he would never return. Seward has put it so well: 'Five minutes of swordsmanship, probably less, had ended not only in the death of Caravaggio's challenger but in his own ruin. Few turning points in the career of a great artist have been so dramatic. The idol of Rome's younger artists, the favourite of cardinals, the man who had painted the pope's portrait, had suddenly become a hunted murderer with a price on his head.'

One event that precipitated Caravaggio's journey south to Naples was the horrible news sometime in July or August 1606 that not only had the Tomassoni family rejected any negotiated

monetary settlement for Ranuccio's death, but that the court in the form of papal tribunal had charged Caravaggio with murder and condemned him to death *in absentia*. Anybody who discovered him in the papal states had the legal right to kill him on the spot and deliver his severed head for reward. Otherwise instantaneous execution awaited him should he be captured alive and brought to Rome. The severed head motif must have been a visual threat that deeply haunted Caravaggio, as decapitation appears so much more often in his paintings than ever before.

Naples, Malta and Sicily 1606–1609

Even in autumn Naples had a very different atmosphere from
that of Rome; its religion seemed not as ominous far from the
watchful eye of the Vatican, yet still the religious authorities
dominated art. As a religious city where spectacular ceremony
and sensationalism were inherent to ritual, there were over 400
churches and 200 convents in early seventeenth-century Naples.
It was ruled by Spanish grandees and a corrupt viceroy, Don Juan
Alfonso de Pimental y Herrera, whose primary job was collecting
the oppressive taxes for Spain. The teeming population of Naples
was several times that of Rome. At least 250,000 Neapolitans
piled up in tenements at least twice the height of Roman build-
ings over straight streets. A previous viceroy, Don Ferrante de
Castro, had commissioned Domenico Fontana to build the
grandiose Palazzo Reale in 1600–02 for the expected visit of
Philip III of Spain which never happened. The *cortigiani* and *mere-
trici* (prostitutes) were also more strident than in Rome and,
according to some, were even more beautiful. Many Baroque vis-
itors to Naples noted the colourful and heady Neapolitan atmos-
phere, and like John Evelyn around 1640, the 30,000 licensed
prostitutes.[31]

Surprisingly, for a hunted criminal, Caravaggio seems to have
mostly avoided legal problems and arrests. Naples was Marzio
Colonna's main residence, and he was on the vice-regal advisory
council there. Other Colonnas lived in Naples, including his
brother Ascanio Colonna who was Cardinal Protector of the
Kingdom of Naples, and Constanza Colonna, the Marchesa of
Caravaggio, the widow of Francesco Sforza whom Fermo Merisi,
Caravaggio's father, had served. Thus old ties of protection were

maintained.[31] In Naples papal authority was weak, tolerant or somehow complicit in Caravaggio's freedom.

Commissions arrived for Caravaggio almost as soon as he did, as if his presence was expected and his criminal status celebrated. Two weeks after arriving from the Alban Hills south of Rome, he received a commission of 200 ducats on 6 October from a wealthy merchant Nicolo Radulovic that may never have been finished. However, the painting was rejected by its owner even though Caravaggio had apparently already spent the commission and money for materials. Not long afterward, in November or December, Caravaggio was paid a much larger sum of 400 ducats for a huge altarpiece, the *Seven Acts of Mercy*, commissioned by the Pio Monte della Misericordia Congregation, a work rapidly finished by 7 January 1607. The subject comes from Christ's Olivet Discourse in the Apocalyptic Matthew 25 and records the prerequisite charities (old biblical Jewish *mitzvot*) 'done to the least of my brethren as unto Me' as saving graces when accounted for in the Last Judgement. Hospitality to strangers and the sick with feeding and clothing them, alongside visiting prisons to succour the incarcerated are all portrayed with additional charity in the office of the dead. Perhaps the most interesting element in the painting is the inclusion of a double charity from a famous old Roman tale in Pliny's *Natural History* 7.121 and elsewhere. This is the tale of Cimon and Pero where a daughter (Pero) visits her starving father (Cimon) in prison – he had been denied food by the tyrant – Peisistratus in some versions – and feeds him from her own ample breast.[32] There were other, more important commissions in Naples, such as the not easily dated *David with the Head of Goliath* in Vienna, and a documented commission for the *Flagellation of Christ* of 200 ducats, apparently in early 1607. This was requested by Tommaso and Lorenzo De Franchi, a well-connected Neapolitan family and is in the Capodimonte Palace in Naples.

Caravaggio set off on a journey to Malta and knighthood there sometime between October 1606 and March 1607. For this it is likely that Caravaggio had assistance and mediation within the Knights of Malta. This assistance could have come in the form of Fra Fabrizio Sforza Colonna, son of Constanza, Marchesa of Caravaggio. Fabrizio was a Knight Commander of Malta and Captain General of the Galleys of the Knights of Malta since 1606. Other possibilities include Fra Ippolito Malaspina, Prior of Naples; the Florentine, Fra Ainolfo Bardi, Knight Commander of Malta, who had helped secure his release from Tor di Nona Prison after the Baglione suit; also Fra Orazio Giustiniani, a cousin of Vincenzo and Benedetto in Rome; and Caravaggio's old Roman patron Ottavio Costa who had two sons in the Knights of Malta. Perhaps most significantly, Caravaggio may have already painted a portrait for the Grand Master of the Knights of Malta, Alof de Wignacourt, who may have sat for Caravaggio and even helped him out personally in Naples between October 1606 and May or June 1607, although it is more likely that Caravaggio painted Wignacourt in Malta soon after his arrival. Caravaggio must have had the help of more than one person to petition to join the Order and to secure passage to Valetta, Malta. Whatever the circumstances, he was invited to Malta quickly after his seven months in Naples and he left Naples even before the maritime weather was settled.

It is possible that before he went to Malta, he travelled to Genoa probably via Livorno, with Fra Fabrizio Sforza Colonna, Captain-General of the Knights of Malta galleys, then back down south to Corsica and Sardinia before stopping again in Naples or another port, thus adding a month or more to his spring to summer journey. Rather, if the southern route were taken directly, it was still a fairly long sea voyage of up to two weeks from Naples to Valetta, especially in uncertain early spring weather. Caravaggio must have travelled as a passenger on a Knights of Malta galley. Even

with variable weather it would have been much safer to go the whole route by water to avoid the ubiquitous Neapolitan and Campanian *lazzaroni* bandits so prevalent from Naples down to Paestum and even Reggio di Calabria.

Upon arrival in Valletta, Caravaggio was somehow quickly accepted as a novice, despite his homicide fugitive status and common birth. This was again due to his patrons and protectors as well as to his acknowledged artistic genius. Normally not open except to those of noble birth, his unusual novitiate was conditional on vows and his obedience. The Knights of Malta, Order of St John of Jerusalem, were an old religious order founded in the Crusades for defence of the Holy Land back in 1099 as Knights Hospitallers (more officially, Sovereign and Military Order of the Hospital of St John of Jerusalem), originally under a monk, Gerard, in a hospital fraternity close to the Church of St John the Baptist in Jerusalem. On Malta as an island and a culture in 1608, Wilson-Smith says: 'The island was unique in Catholic Christendom, being a sovereign state presided over by a religious fraternity that had been set up for the care of the sick, but which had become the senior order of chivalry.'[33]

In 1530, the Habsburg emperor Charles V gave Malta to the Knights Hospitallers, since the Turks had conquered Rhodes, their former centre after the Holy Land was reconquered by the Muslims at the end of the Crusades. One of their primary duties in 1607 was the defence of Christendom with their splendid fighting navies, famous for their red and gilded hulls, especially strong against Ottoman Turks and Barbary pirate corsairs, although they still maintained excellent hospitals.

For Caravaggio all this military and aristocratic history would have been moot, as he was not descended from knights whereas other novices would have been easily able to relate to venerable Crusades, long bloodlines and lengthy religious service. All novices and knights took vows of poverty – at least in spirit –

along with chastity and obedience and daily recital of certain reli-
gious offices as well as frequent Confession and Mass. Each one of
these strictures would have been strange for the wild Caravaggio,
the least likely candidate, unless he was genuinely penitent and
determined. Caravaggio must have somehow persuaded Alof de
Wignacourt and others that he was seriously bound to follow
these rules, however difficult. He seemed to want this knighthood
so badly he would endure both hell and purgatory for it. What
would his carousing Roman friends have said to see Caravaggio in
the habit of a monk and in a religious order? No doubt they
would have shaken their heads and wondered how long he could
stick it out.

Alof de Wignacourt, Grand Master of the Knights of Malta
since 1601, sympathized with Caravaggio and as a result penned
a petition for a papal dispensation, written on 7 February 1608.
Wignacourt's request was terse but strong: 'Most Holy Father,
Since the Grand Master of the Order of St John of Jerusalem
wishes to honour some virtuous and worthy persons, who have a
desire and devotion to dedicate themselves to his service and to
that of his Order . . . he humbly begs Your Holiness to deign a
grant to him, by a brief, the authority and power for one time
only, to decorate and adorn with a Magisterial Knight's habit two
persons of whom he as Grand Master [Wignacourt] had a high
opinion and whom he is nominating, although one of them has
committed a homicide during a street brawl.' Pope Paul V knew
immediately it was Caravaggio in question and must have been
prepared by Del Monte and others. Normally being in a novitiate
was a process taking up to a year, in which period the novice could
be watched. In this case after Caravaggio's partial novitiate of only
seven months, Pope Paul V responded quickly on 15 February
granting Wignacourt's petition: 'For Alof de Wignacourt, Grand
Master of the Hospital of St John of Jerusalem, Authority to pres-
ent the habit of Magistral Knight to two persons favoured by him

although one of the two had committed homicide in a brawl. It pleased the Most Holy Father to approve.' The other new knight was probably Count de Brie, the illegitimate son of the Duc de Berry.[34] Both Wignacourt and Pope Paul knew Caravaggio's election must have been abnormally provisional and strongly conditional, so we have to assume Caravaggio knew this as well.

After completing his year-long novitiate, on 14 July 1608 the Grand Master issued this Bull of Reception mandating that the 'Reception of the Honourable Michel Angelo da Caravaggio as Brother and Knight of Obedience . . . Whereas the Honourable Michel Angelo, born in the town of Caracca in the vernacular called "Caravaggio" in Lombardy, having been called to this city, burning with zeal for the Order, has communicated to us his fervent desire to be adorned with our habit and insignia . . . We receive and admit him to the rank of Brethren and Knights of Obedience.' The Bull of Reception also includes this phrase which identifies the reason for admittance as an artist: 'this adopted disciple and citizen with no less pride than the island of Kos, also within our jurisdiction extols her Apelles and that we should compare him to more recent artists of our age . . . outstanding man of equally important name and brush.' The famous artist Apelles (fourth century BC) painted for Philip II of Macedonia and his son Alexander the Great, was considered the best painter of the Greek world by Pliny and others, and Spike rightly suggests this umbrella clause both identified the order with artistic precedent in Apelles of Kos which island they now ruled and thus established their authority to entitle another great artist.[35] Which was stronger for Caravaggio, his religious zeal or his desire for knighthood?

For his knighthood Caravaggio painted a huge masterpiece (361 × 520 cm) that would remain after his own unfortunate departure from Malta, with its traditional yet innovative choice of subject. His *Beheading of St John the Baptist*, 1608, shows the death

of the martyred patron saint of the order, an altarpiece that would preside over knightly investiture and ironically, in Caravaggio's case, disvestiture as well. The almost naked executioner has already mostly severed John's head with a sword, which is lying under the dying saint and wields a dagger to finish the task. The jailer who has a set of iron keys hanging from his belt, points at the copper charger, held by the girl, possibly even Salome herself, on which John's head will soon go. The balance of this painting is

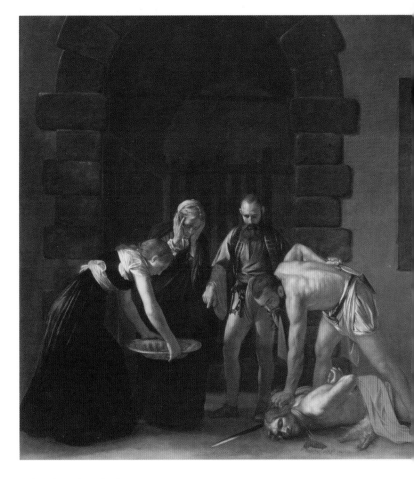

Beheading of St John the Baptist

well planned, the arching quartet of prison personnel echoes the quoined arch of the prison; the hands of the horrified old woman rise to her face while the hands of the young woman stretch down for the head; the bending of the executioner is balanced by the bending of the girl; the bare body of the executioner matches that of the dying saint with opposite arms pulled back. The quartet of people on the left is balanced by the two prisoners peering in through the bars on the right. Furthermore, John's red blood

spills in an inverse proportion to the red mantle. Caravaggio even signed his name in the martyr's blood as *F Michel* . . . his only known signature. This is highly unusual for multiple reasons, not the least of which is his use of 'Fra' now that he is a fraternal knight monk. Using blood for the signature, especially that of the martyr John, may also be, as Puglisi suggests, his penitential identification with the martyr and the order as a form of expiation for the blood of Ranuccio Tomassoni.[37] The intriguing bold placement of the signature at the bottom of the painting and thus directly above the altar would be clear to the Knights of Malta. The sacrificial lamb motif of the martyr also anticipates Christ's propitiatory sacrifice as *Agnus Dei*

slain for the sins of the world, also indicative of Caravaggio's homicide and lawlessness. Few would challenge Bellori's comment that 'In this painting Caravaggio used all the force of his brush, having worked with such boldness that he left the priming of the canvas in half-tones.' Wignacourt as Grand Master of the Knights of Malta was duly impressed with his achievement for knighthood, so much so that 'besides honouring him with the cross, the Grand Master also gave him a precious golden chain and made him a gift of two slaves among other things, as a sign of his esteem and satisfaction with his work.' It would have been transparent to Caravaggio that like Cesari the Cavaliere d'Arpino, now he not only belonged to one of the oldest knighthoods in the world but also had an equally valued gold chain to wear over his crossed habit. He was a new man, a *nuovo uomo gentile* as well as the *valentuomo* he had always considered himself to be. His investiture was on 14 July 1608 when he knelt and was given the red silk surcoat with its white cross, followed by the black crossed habit and stole of a Knight of Malta in the Order of St John underneath his own masterpiece painting.

Caravaggio must have painted several other works in Malta in 1608, including *A Knight of Malta*, a portrait of another high knight, Fra Antonio Martelli, also in his black habit with the white cross, now in the Pitti Palace in Florence, along with a *Sleeping Cupid*. Possibly at this time (or before in Naples in 1607) he also painted Fra Ippolito Malaspina as *St Jerome Writing,* now also at Valletta.

But disaster struck almost as soon as his new good fortune. Caravaggio appears to have lost his humility of spirit and his pride rose up swiftly. For in the following months, Caravaggio sensed that some in the order were not as impressed with his genius as others. There must have been a verbal conflict, wherein the first biting words came from a very noble (and anonymous) Knight of Malta seeking to put the proud younger knight in his

place. The insulting knight was at least a Knight of Justice (requiring a minimum of 200 years of nobility in all four family quarters of grandparents) and Bailiff Grand Cross, an office for the highest nobility. But the gulf in rank and prestige didn't matter to Caravaggio who went into a rage and attacked this other knight, probably with his sword and apparently wounding him badly. As Bellori wrote: 'But all of a sudden his turbulent nature caused him to fall out of this prosperous state and out of the Grand Master's favour, because of a very inopportune quarrel with a most noble knight he was put into prison and reduced to a state of misery and fear.' His fight could easily be interpreted as attempted murder, especially considering the difference in nobility, rank and age. Caravaggio had his only chance at rehabilitation and lost it. That was all that was needed to swiftly remove his new knighthood and summarily expel him from the order forever. He had been safer than ever in his life while in Malta and he threw it all away. He was arrested almost immediately by a Grand Viscount of the order and put into the formidable prison dungeon of the Fort Sant'Angelo in chains and under guard. His was a maximum security stone cell cut into bedrock eleven feet deep. How his fallen pride must have anguished him now in the dark cell.

Bellori states that Caravaggio escaped from the prison in Malta, which would have been impossible on his own. 'In order to regain his freedom he exposed himself to the gravest danger and escaping by night, he fled undetected to Sicily with such speed he could not be recaptured.' But however resourceful Caravaggio might have been, the Fort Sant'Angelo was a military prison heavily guarded by soldiers and fighting monk knights. He must have had help on the inside, including a rope to climb out and a boat to get away sometime around 6 October 1608. It is more than likely that his help was from the highest level, possibly Alof de Wignacourt himself or possibly Fabrizio Sforza Colonna. If so,

Wignacourt must have personally liked Caravaggio. Caravaggio is next documented in Siracusa, Sicily, almost immediately and is not captured despite commands to search for him. This too confirms protection by someone high up in the Knights of Malta since their navies were so entrenched in Siracusa. Caravaggio was ceremonially expelled *in absentia* under the very painting for which he had been knighted. A white-crossed black habit was ritually stripped from a stool under the altar in a *Privatio Habitus*, 'Loss of the Habit'. Although he would refuse to admit or accept this humiliation, Caravaggio could no longer be called, or legally refer to himself as, a Knight of Malta. Caravaggio must have been devastated and as a result his art changes significantly after Malta: a palette of limited colours, primarily red, black or brown and white, scenes far more sombre and subdued. One thing is certain: he now had an enemy far more powerful than the Tomassoni family in the 'Most Noble Knight' he had severely wounded. He had alienated most of those who had protected him to date, including the Order of the Knights of Malta whom he had now greatly embarrassed and angered. The strong arm of the noble Knights of St John had a long reach if they wanted to find him, although events suggest he was left alone temporarily.

Despite his shamed status, Caravaggio was greeted almost immediately by the civic senate of Siracusa in October 1608 which seem to have commissioned a painting of their patron saint, Lucy. He was also welcomed by an old friend and former fellow carouser, the artist Mario Minniti, who had a thriving studio in Siracusa, his home town. In late 1608 Caravaggio painted his *Burial of St Lucy* as the altarpiece for the Basilica Church of Santa Lucia al Sepolcro. Lucy was the patron saint of Siracusa, a second to third century AD virgin martyr of the catacombs in the Palaeo-Christian quarter of the city in the old Tyche district where the prisoner St Paul visited en route to Rome. Perhaps it is Lucy's betrothed who is stoled in red and with hands

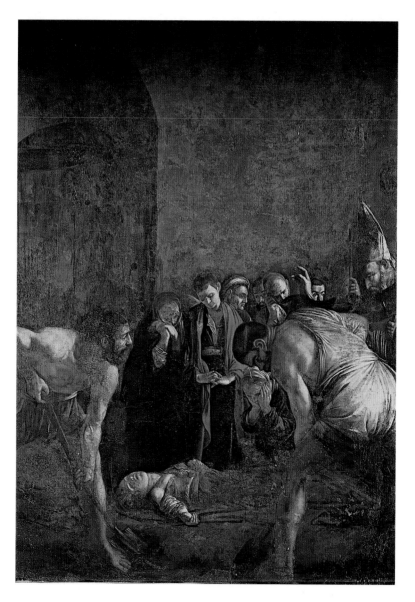

Burial of St Lucy

folded over her. If so, he would have reason to repent as the *Legenda aurea* names him as her pagan betrayer enraged that she refused to marry him as a Christian after she donated her dowry to the poor. A repainted area shows Caravaggio originally had her head hanging by a thread, redone to only show the neck wound in the version preferred by the town elders. Also, as an intentional result of the *pentimento*, Lucy's head is thrown back in an apparent saint's ecstasy, like that of the earlier St Francis only even more pronounced. Such a sainted virginal ecstasy would be ironic since the *Legenda aurea* relates

> 'Lucy comes from *lux* which means light. Light is beautiful to look upon, for as Ambrose says, it is the nature of light that all grace is in its appearance. Light also radiates without being soiled; no matter how unclean may be the places where its beams penetrate, it is still clean. Thus we are shown that the blessed virgin Lucy possessed the beauty of virginity without trace of corruption.'
>
> St Lucy: Thirteenth-century *Legenda aurea* 27 on St Lucy (by Jacobus de Voragine).

how the angry Roman prefect Pascasius – who may have been converted by her testimony and is now present – attempted to have Lucy raped by 1,000 soldiers in a brothel, but it was a failure; as was her prior arrested marriage to a pagan. Yet now in death she is the virgin bride of Christ himself, which makes Lucy's ecstasy eternal as Caravaggio intriguingly depicts it here.

On a different note, might there be a more personal, biographical connection in the *Burial of St Lucy*? Caravaggio's mother was Lucia Aratori. Is there a possible subtext in the picture long after his mother's death that it is also refers to his mother Lucia's burial and that the young man standing by – highlighted with the red stole – and clearly the most pensive and helpless bystander with black hair among the mourners is the young Caravaggio himself? The painting now in the Palazzo Bellomo Museum has been much conserved after extensive damage on its lower side from neglect.

One Siracusan story about Caravaggio may be more than mere

anecdote. Caravaggio seems to have enjoyed the Greek ruins in Siracusa, including the theatre, and more importantly, viewed the huge Latomia limestone prison quarries where thousands of unransomed Athenian prisoners perished after their unsuccessful invasion in 413 BC. From a small cell in the Paradiso quarry wall, the paranoid tyrant Dionysus I – the same tyrant who hung a sword by a thread over the head of Damocles – used a twenty-metre-high legendary crack in the rock with amazing acoustic amplification where he secretly listened to purported plots. Caravaggio is reputed to have been the first one who pointed out the quarry fissure's acoustic resemblance to a human ear, hence the name *Orecchio* ['ear'] *di Dionisio*.

Caravaggio remained in Siracusa a few months with Minniti then made his way north up the Sicilian coast to Messina in late autumn. This is equally curious because of a Knights of Malta priory there and a large contingent of knights. After his flight, although he may have been ceremonially expelled from the order as late as December 1608, he seems to have still used his title of Knight of Malta in Messina. Again, no one from the priory or the resident Knights of Malta seems to have disturbed Caravaggio although he was apparently very worried, as the Sicilian chronicler Susinno reports he slept with a dagger under his pillow. He must have been alert to the danger he was in, still so close to Malta and to a large mobile population of Knights of Malta. Also according to Susinno, 'the unquiet nature of Michelangelo . . . which loved to wander the earth, soon after led him to leave the home of his friend Minniti. He then went to Messina.'

'[In Messina] . . . Michele went to observe the positions of those playful boys and to form his inventions. But the teacher became suspicious and wanted to know why he was always around. That question so disturbed the painter and he became so irate and furious, that he wounded the poor man on the head.'

Susinno (1724) on Caravaggio's time in Messina

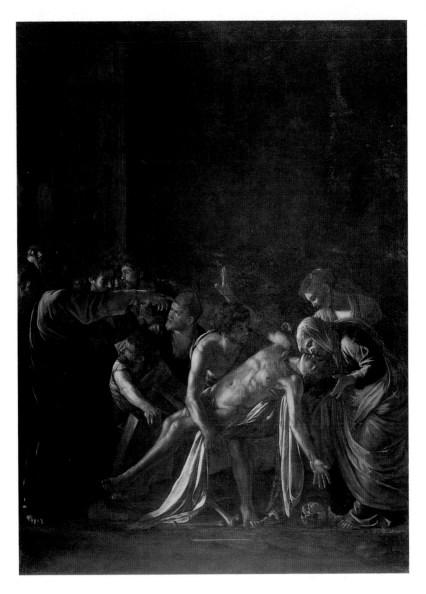

Raising of Lazarus

In Messina through the winter from early 1609, Caravaggio was quickly commissioned by Giovanni Battista de Lazzari, a Messina businessman from Lombardy, to paint the *Raising of Lazarus* mostly from the New Testament text of John 11:1–45. This painting is probably a pictorial pun faithful to the patron's name. Jesus came to Bethany only to find Lazarus had died from a virulent quick sickness and the lamenting Mary and Martha had upbraided Jesus for not coming sooner. In response to Jesus' command that they go to the tomb and open it, the sisters said, 'But Lord, he stinks after four days!' Caravaggio paints again a scene in the lower half of the canvas only. He may allude to the stench, about which the assisting and incredulous bystanders seem to be upset. They unwrap Lazarus' body, which is stiff with *rigor mortis*, then in response to Christ's command, 'Lazarus, come forth!' his dead body slowly begins to move, at first only one hand lifted and opening perpendicular to the hand of Jesus, a likely quotation of Michelangelo's Sistine Chapel God and Adam motif. The deliberate positioning of Lazarus' body also looks exactly like that of someone who was taken down from crucifixion with arms splayed and feet crossed and therefore foreshadows Christ's coming death and resurrection. Under Lazarus the skull and bones of a previous burial show where he would have soon been without Jesus' divine intervention. Despite its surface morbidity, this painting seems to say much about faith.

The subjects are to be treated 'according to the ideas of the painter (*capriccio del pittore*)' and he is to be paid 'as much as is fitting for this painter who has a crazy brain'.

Words of a wealthy noble patron, Nicolo di Giacomo, Messina: Sicily (from Langdon, 376).

Perhaps after painting a much-debated *Narcissus* in early to mid 1609 (or possibly later in Palermo) whose initial attribution by Longhi to Caravaggio is still debated along with its Sicilian chronology, Caravaggio undertook additional rapid commissions. Based on an archival document from Ligurian Savona, a fiscal document of 1645 of 'a Narcissus

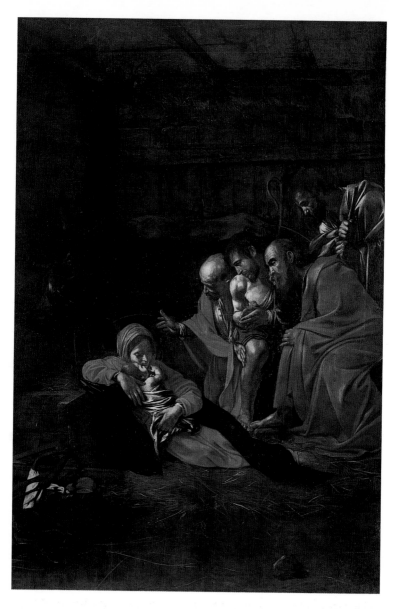

Adoration of the Shepherds

from the hand of Caravaggio', the document and style seem to merit the attribution.[38] The *Narcissus* gazing at his own reflection may be a possible allusion to both Ovid's *Metamorphoses* III.407 ff. and Dante's *Inferno* XXX: 129 ff. Some suggestions that the painting may go back to Caravaggio's Roman period are still valid if its commissioner was in fact Vincenzo Giustiniani. For Bernardo Castello sculpted a *Narcissus* for Giustiniani in 1604–05 and a friend and patron of Caravaggio in Rome, the poet Cavaliere Giovanni Battista Marino wrote about Narcissus as a possible Caravaggian *ekphrasis* also around the same time. As many have pointed out, Narcissus is said to be the one who invented painting in Leon Battista Alberti's 1565 *On Painting* where he ruminates: 'For this reason, I say among my friends that Narcissus who was changed into a flower, according to the poets, was the inventor of painting.' Although no flower is visible in Caravaggio's Narcissus other than on the abstract velvet pattern of the shirt on his back – which is perhaps sufficient since he wears it – this idea could make it a Caravaggian allegory of the danger of self-love.

The Messina town senate then commissioned Caravaggio to paint a traditional *Adoration of the Shepherds*, probably in the summer of 1609 for their Capuchin chapel, the Church of Santa Maria della Concezione. While some might find it controversial for placing an exhausted Mary in the dirt and straw, Caravaggio's originality is assured. Ox and ass evoke the old allusion to Isaiah 1:3 where 'the ox knows its owner, the ass his master's crib.' Mary's supine body cradling Jesus is fascinatingly partly paralleled in the young shepherd's cradling gesture and his body hunched in empathetic tenderness. The line of sight of the shepherds and Joseph moves down from upper right all the way to weary Mary where it intersects back to the lower right and oblivion as she meditates and ponders maternal burdens all by herself. The gaze of the infant upward, however, sends the viewer back up the diagonal again. Caravaggio has invested a traditional theme

and iconography with new meaning and the characteristic humility of real people.

Susinno related two additional tales about Caravaggio in Messina, both of which are plausible. Caravaggio is said to have assaulted a schoolteacher who was angry at Caravaggio's putative obsessive interest in children playing at the school. Then briefly attending the Church of the Madonna del Pilero, Caravaggio perhaps jokingly turned down the holy water at the church entrance because it would cleanse only venal sins, responding, *I don't need it because all my sins are mortal.* After leaving Messina and travelling to Palermo, possibly on the run and nervous about perceived threats from the Noble Knight of Malta he had wounded and who had now recovered, Caravaggio returned apparently suddenly to Naples in October 1609.

Despite words of a petition – possibly spearheaded by the still mediatorial Del Monte and the eager Scipione Borghese who sought more paintings – which would have allowed his return to Rome with a possible pardon for murder after three years, Caravaggio was still a fugitive and a criminal with vengeful enemies. In Naples, he again lived in Santa Chaia district in the Colonna palazzo of Constanza, Marchesa of Caravaggio, his old patroness who had known his father well in Milan. At this time he had nowhere else to go except to the Marchesa da Caravaggio. To Caravaggio it must have seemed a full circle of his life, albeit an unhappy one.

'The perverse embrace of sex and religion was everywhere in the painting of the Counter-Reformation . . . Nailed hands, rolling eyes, exposed breasts, floating veils, bleeding wounds, cherubs' heads on wings – the dire panoply that would become the standard catholic iconography for the next four hundred years. Secular reading offered a related mix of sex, death, frustration, incest, pain, voyeurism, nymphomania, paedophilia, sadism, repentance. In this chamber of horrors, the freshness and frankness of M's pictures were stunning.' Peter Robb: *The Man Who Became Caravaggio.*

Ars Moriendi or Ars Mortis 1609–1610

How safe was Caravaggio in Naples in the autumn of 1609 and winter of 1610? Apparently not very, as he was assaulted and seriously wounded by four attackers in a fight outside the Osteria del Ciriglio, an infamous waterfront tavern in Naples, possibly by *lazzaroni* or perhaps by those who knew he had a double price on his head from either direction, the Tomassonis in Rome or now the Noble Knight of Malta seeking revenge against a criminal. He was left for dead, with his face badly disfigured. Baglione says: 'In Naples the enemy finally caught up with him and he was so severely wounded on the face that he was almost unrecognizable.' Bellori added, 'Fear drove him from place to place [in Sicily] . . . feeling that it was no longer safe to remain in Sicily, Caravaggio left the island and went back to Naples, where he thought he would stay until he heard word of his pardon and could return to Rome . . . Having stopped one day in the doorway of the Osteria del Ciriglio on the quayside, and having been surrounded by some armed men, he was beaten up and badly wounded in the face.' Caravaggio had few friends and companions in Naples and it is surprising he would frequent a notorious lowlife tavern unless he sought a prostitute or some other solace. Perhaps he was seeking cheap or secret passage to Rome's ports. It was unfortunate that Caravaggio was alone at the tavern and his pain of solitude turned to deeper anguish with his bodily injury from which it would take time to recuperate.

Two or three possible last paintings suggest the state of mind of Caravaggio in Naples before his fatal journey towards Rome in 1610. His *Annunciation* (1608–10) is a most solitary work. A poignant Mary kneels in her blue *maphorion* mantle on the floor.

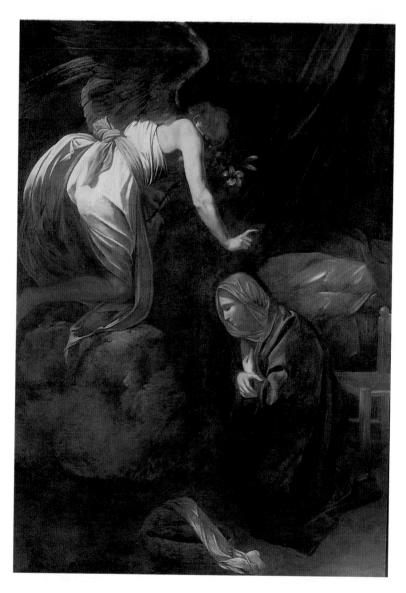

Annunciation

She is remarkably humble before Archangel Gabriel whose face is in shadow and blocked by his arm. His right finger points ambiguously either to the empty bed or perhaps slightly heavenward where a traditional iconography would derive the source of the Incarnation. Although Caravaggio follows convention in having the Madonna *lilium album* in the angel's left hand, there is no dove of the Holy Spirit to represent conception, a startling omission. Could this be a rejected painting by the Messina senate and the Santa Maria della Concezione where a second more traditional Nativity was accepted? No documentation supports this twist for a painting ending up in the Musée des Beaux-Arts in Nancy, France. However, Caravaggio represents something far more miraculous than a floating bird: in place of the dove he shows a billowing cloud under the angel where some imagine the face of God. If these are possible hermeneutics, this is a stroke of Caravaggian genius. Furthermore, a rare flat profile by Caravaggio suggests a Byzantine aspect of Marian tradition. He depicts a most rare humility, since she is not the Queen of Heaven before whom angels bow but the simple 'handmaiden of the Lord' kneeling before an angel on the floor. Many pious viewers might fault Caravaggio's startling iconography despite the loveliness of Mary's burdened humanity, so pure in her beautiful humility.

Not one to shy from self-portraits embedded in his paintings, Caravaggio seems to feature an increased number during this late period. His *Martyrdom of St Ursula* of 1610, was painted for Marcantonio Doria in Genoa. In this, he departed greatly in the iconography from the usual spectacle of 10,000 virgin martyrs killed by pagan Huns and concentrates only on the central event of Ursula's death at the hand of the Hun chieftain. Perhaps the most interesting element is that Caravaggio painted himself behind Ursula with a surprised look on his face. Since when was Caravaggio surprised by violence?

The last painting, perhaps even chronologically, is his repetition

of the theme of *David with the
Head of Goliath* (at least his
fourth version, like his ample
John the Baptist beheadings),
probably painted in Naples in
1610. This painting was among
those pilfered at his death or just
before by paid assailants or sol-
diers, and resurfaced with
Scipione Borghese a year
after Caravaggio's mysterious
death. Of the thirteen or more
altarpieces and maybe an equal
number of portraits or smaller
paintings done after his flight
from Rome,[39] this picture is per-
haps the most startling. It may
represent the face of a youthful
Caravaggio as David holding the
head of the Goliath whose face is
definitely the adult Caravaggio.

As a mirror of reality, it vicariously fulfils the threat of 'severing
his own head to present it to a judge' for the capital punishment
awarded Caravaggio over the murder of Tomassoni. As champion
of Israel in I Samuel 17, the emotion on David's (Caravaggio's?)
young face is that of tight-lipped, brow-furrowed distaste or
repugnance at his sad task. Goliath's (adult Caravaggio's) features
show slack-jawed death troubling the painter only a few moments
more before oblivion greets the artist's sightless eyes – an enor-
mous paradox for a painter of such visually detailed and realistic
genius – and his own life ceases to vex him with his many mortal
sins. Caravaggio maintains in the picture that there is no hope of
pardon from earthly prelates. It is both a prophetic and a tragic

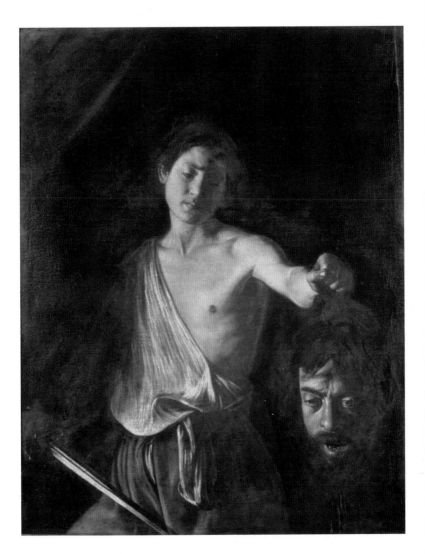

David with the Head of Goliath

vision of self-fulfilment, a confession that he had reached his limit.

When Caravaggio set out for Rome in mid-July, 1610 probably filled with anxiety even though he was anticipating some small help from Cardinal Gonzaga and his Colonna protectors, he must still have expected trouble at nearly every step of the way, every wind-filled turn of the boat bringing him up the coast. Looking hard at everyone around him to see if they would betray any treachery or give away vengeful intentions, he must have been unimaginably lonely and insecure. It may have only been a stubborn blind faith that kept him going when reason might have told him to suspect a trap. Bellori says: 'After boarding a felucca as soon as it was possible, suffering the acutest pain, he headed for Rome, having by then obtained his liberation from the pope through Cardinal Gonzaga's intercession. Upon his arrival ashore, the Spanish guard, who was waiting for another knight, arrested him by mistake and held him prisoner. Although he was soon released, he could no longer see the felucca which had carried him and his possessions. Thus wretchedly shaken by anxiety and despair, running along the shore in the full heat of the summer sun, having arrived at Porto Ercole, he collapsed and, seized by malignant fever, died within a few days at about forty years of age.' Bellori may possess some of the facts, but probably not all, and although mostly in agreement, Baglione adds a few details: 'He boarded a felucca bound for Rome with a few of his belongings, on the assurance that Cardinal Gonzaga was negotiating with Paul V for his pardon. When he got ashore he was mistakenly captured and put into prison where he was held for two days. On his release, unable to find the felucca, he made his way along the coast in desperation under the cruel heat of the summer sun, trying to catch sight of the vessel at sea that carried his belongings. Finally reaching a place of habitation along the shore, he was put to bed with a malignant fever, and after a few days, without

human succour, he died as miserably as he had lived.' Mancini's details are skimpy, stating only that 'Having left there with the hope of being pardoned, he arrived at Porto Ercole, where stricken with a malignant fever, he died alone, in pain and hardship at the height of his glory, at the age of about thirty five or forty, and was buried nearby.'

It must be remembered that all three of these accounts are a long time after the event, Bellori's from 1672 more than sixty years later, Baglione's from 1642 more than thirty years later and Mancini's from 1617–21, still about a decade later. The more contemporary accounts are from letters within the month of Caravaggio's death, July 1610, and they tell a somewhat different story. There is first a letter from Giovanni Lanfranco dated 24 July which stated that 'Caravaggio died at Procida.' Scipione Borghese's agent, Fra Deodato Gentile, Bishop of Caserta, Naples, writes to him after his inquiry thus, both negating and expanding on Lanfranco's account: 'Most Reverend Respectable Patron, I deny what has been reported in the letter of the Most Illustrious Lanfranco of the 24th of the present month to Your Most Illustrious Lordship about Caravaggio the painter: which being to me unknown, I tried to get information about it, and I find that poor Caravaggio has not died in Procida but at Porto Ercole, because having arrived at Palo aboard the felucca on which he sailed, he was there put into prison by that captain, and heard that the felucca set sail and returned to Naples; Caravaggio having remained in prison, got his freedom by paying a large amount of money, and by land and perhaps walking, he went as far as Porto Ercole, where falling ill, he lost his life.' Gentile then mentions, since Borghese has been inquiring about possessions, that only three of the paintings Caravaggio seemed to be carrying can be accounted for, 'two Saint Johns and a Magdalene' and these three were back secure in Naples at the Chaia palace of the Marchesa Constanza Colonna da Caravaggio.

Many details of Caravaggio's death need resolution that will probably be for ever lost. Procida is the island just outside Naples at the north end of the Gulf of Naples. Palo is an obscure stop near the mouth of the Tiber flowing from Rome, not a known port and then infested with malarial swamps. But Porto Ercole with a Spanish garrison was far north from any good Roman port, as Robb confirms, as far north of Rome as Naples was south.[40] The normal Roman port other than Ostia was south of Porto Ercole at Civitavecchia, so what was Caravaggio doing so far away at Porto Ercole?

Letter from Diego de Albear, Captain of the Spanish Guard at Naples, Summer, 1610
'Cardinal Borghese has given me an order to capture a bandito from the papal state who is in Naples and is a most famous bandito (bandito famisissimo)' –
Was this Caravaggio and was this why, he was arrested – mistakenly or not – by the Spanish garrison at Palo? (Robb, 486)

Whether he was murdered somewhere between Procida and Palo, or killed after being arrested by the garrison commander, as many think, or died of malarial fever at the Spanish garrison of Porto Ercole after attempting to cross the coastal swamps southward, or was just an anonymous victim of *lazzaroni* and *banditi* – thus a backward swing of the pendulum of justice – there was a definite transportation problem en route. Things certainly did not go as planned for the thirty-nine-year-old genius. The posthumous reports may shelter a cover-up. His manner of death around 18 July 1610 is still unsolved; his body was never found. It is most likely that he died of fever and not some nefarious conspiracy, given the archival document discovered by Maurizio Marini in 1995[41] in the Confraternity of Santa Cruz at Porto Ercole as Seward explains: 'Fresh light on the painter's death and burial . . . He died from drinking polluted water, contracting some lethal form of enteric fever. He did not die alone . . . but was nursed by the Confraternity of Santa Cruz . . . Its members . . . saw that dying

wayfarers received medicine and the Sacraments . . . They owned the little Chapel of St Sebastian near the sea, next to Fort Filippo, which had a small garden with two palm trees. They interred him there, between the palm trees. Despite the fact that it was a pauper's burial, it was unlikely that the confraternity robbed his corpse. The chapel is still standing, no longer a place of worship, and although his grave has not been found, Caravaggio must lie nearby, rapier and dagger [probably] by his side.'

Caravaggio's art of dying over and over in vicarious rueful antic-ipations are there in his incredible paintings. Yet he was a prod-uct of his turbulent time so that the repeated violence in his life and paintings is not as remarkable as it might seem. Many psy-choanalytic attempts to understand Caravaggio's 'craziness' out-side of his contemporary context have perhaps stressed his stormy life as symptomatic of great inner turmoil and deep antisocial pathology;[42] others simplistically suggest that art itself is a prod-uct of pathology. Yet psychobiography has a tendency to project modern trauma back to past figures whose lives, however com-plex, cannot fit so easily into disorders, neuroses and behavioural syndromes.[43] Was Caravaggio really a hardened criminal addicted to violence as his detractors would have it? Probably not. A non-conformist, a sceptic as well as a swashbuckler and even 'fast-draw' swordsman, most definitely. But a non-conformist is by no means a hardened criminal given the heightened moral code and hypocrisy in Counter-Reformation Rome where 658 executions took place between 1592 and 1606, his very years in the city, as Varriano magisterially points out. This is easily congruous with a religious atmosphere that stressed the graphic realities of martyr-dom and Christ's Passion in explicit detail so that a deeper iden-tifying with Christ and the saints would be enabled by their grue-some deaths.[44]

Caravaggio's many arrests may not be as dramatic measured against the background of Rome in 1606. The truth about

Caravaggio's nature must lie somewhere between the extremes of denigration and hagiography. He did have a prickly pride that reared frequently. Was his honesty in detail also extended to what he knew about himself? Probably yes, if we interpret his many self-portraits in settings of less than ideal circumstances: prisons, beheadings, punishments, conversions and penances.

On the other hand, his fidelity to biblical iconography and personalizing stamp on visual biblical narrative – albeit in contemporary dress – rather than conventions shows both stubbornness and a possible real faith. Some have tried to assemble a cohesive picture of his religious beliefs, others at least detail how daunting the task must be,[45] but assembling his theology from his art and his few extant public statements is monstrously difficult. Perhaps the period in Malta is our best picture of some of his personal beliefs put into daily practice, as he must have been sufficiently persuasive to Wignacourt and others during his fraternal novitiate with the many confessions, communions, liturgies and daily offices. Sadly, this period came to an ignoble end after only a year. Suffice to say that unlike many of his contemporary artists, he consistently chose the simplicity of biblical text and narrative over the canonic and typical interpretations of stock subjects, either because he genuinely saw them differently or perhaps because he just needed to be different himself and to set his art apart. Two important tendencies in his

religious imagery seem to be that humanity is more important than divinity and that saints are the same as sinners. These might appear to be almost modern sympathies in that they are so far in advance of the typical Counter-Reformation ideologies.

For sure his immense legacy for realism and visual drama in an age when Mannerism held sway is still being measured. As Longhi noted, eighteenth-century opinions differed across the spectrum. Palomino, a Spanish critic in 1724 'called Velásquez no more than a "Second Caravaggio" (*un Segundo Carabacho*)' whereas 'the artist Poussin described Caravaggio as a destroyer of art.' His reach and vision extended beyond Ribera and Rembrandt even into the Romantic Era with artists like Goya and Caspar David Friedrich, themselves reacting against similar artifice in the Neo-Classical and Rococo periods, and beyond to the nascent realism of Courbet. With eyes that received the physical light the same way all human eyes do, Caravaggio may not have seen reality any differently until he manipulated the light source like a sculptor working in three-dimensionality, as already stated by Bellori, 'he never brought any of his figures out into the daylight but found a way to paint them against the darkness of a closed room . . . taking a high lamp that hung vertically over the principal part of the body and leaving the rest in shadows.'

His lifelong preference for everyday models and contemporary scenes that were mimetic was puzzling to his critics like Bellori: 'He was satisfied with that invention of nature without further exercising his brain;' this contrasts greatly with this same critic's estimation of Caravaggio's 'taking away all artificial ornament and vanity of colour'. The removal of 'artifice' and 'vanity of colour' and reduction of epic scenes to intensely personal and confrontational scenes in his canvases may say something about his personality as well as his studio, but exactly what is not easy for the historian to establish. Removing artifice in background and extraneous colour is, however, a just description of his method.

Perhaps Bellori's vacillating criticism can be Caravaggio's best aesthetic philosophy for a *valentuomo*, the *sine qua non* of a good artist: 'He claimed that he copied his models so closely that he did not take credit for even a single brushstroke; his brushstroke, he said, was not his own, but nature's, and repudiating all other rules, he considered not being bound to art as the highest form of art.' If true, this indirect statement about Caravaggio's own words sounds far more like a rare humility than the swaggering pride of which he seemed often guilty. Somehow Bellori's countercharge of Caravaggio's art being 'very harmful in that he turned upside down everything that was beautiful and in the best tradition of painting' is far from persuasive, certainly not as plausible as the last statement above and his following curious praise: 'Without doubt Caravaggio advanced the art of painting, for he came upon the scene at a time when, realism being not very much in evidence, figures were drawn according to convention and in a mannerist way, and the taste for beauty was better satisfied than that for truth.' This is an aesthetic very different from later poetic equivocations, somewhat rhapsodic and not always coherent, that 'Truth is beauty and beauty truth,' as Keats borrowed it. Bellori's bitter epitaph that Caravaggio wished to 'die as miserably as he lived', seems hyperbole, for even in untimely death, Caravaggio must have somehow been persuaded of his genius and his ultimate immortality. Caravaggio's genius can be gauged not just in terms of influence but in how much art changed after him and because of him.

SELECTED REPRESENTATIVE PAINTINGS (DATES RELATIVE)

1593	*Boy with Basket of Fruit*	Galleria Borghese, Rome
1593	*Bacchino malato*	Galleria Borghese, Rome
1594	*Fortune Teller*	Pinacoteca Capitolina, Rome
1594	*The Card Sharps (I Bari)*	Kimball Art Museum, Fort Worth
1595	*Musicians*	Metropolitan Museum, New York
1595	*Boy Bitten by Lizard*	National Gallery, London

1595	*Lute Player*	Hermitage, St Petersburg
1596	*Still Life – Fruit Basket*	Pinacoteca Ambrosiana, Milan
1596	*Bacchus*	Uffizi, Florence
1596	*Rest on Flight to Egypt*	Doria Pamphilj, Rome
1596	*Penitent Magdalen*	Doria Pamphilj, Rome
1597	*Medusa*	Uffizi, Florence
1597	*Jove, Neptune, Pluto*	Villa Ludovisi-Boncompagni, Rome
1598	*Judith and Holofernes*	Palazzo Barberini-Nazionale di Arte Antica, Rome
1599	*St Catherine of Alexandria*	Thyssen-Bornemizsa Collection, Lugano
1599	*Conversion of Magdalene*	Detroit Institute of Fine Arts
1599	*Calling of St Matthew*	Contarelli Chapel, San Luigi dei Francesi, Rome
1600	*Martyrdom of St Matthew*	Contarelli Chapel, San Luigi dei Francesi, Rome
1600	*Crucifixion of St Peter*	Cerasi Chapel, Santa Maria del Popolo, Rome
1600	*Conversion of St Paul*	Prince Guido Odescalchi, Rome
1600	*Conversion of St Paul*	Cerasi Chapel, Santa Maria del Popolo, Rome
1601	*Supper at Emmaus*	National Gallery, London
1602	*St Matthew and the Angel*	Contarelli Chapel, San Luigi dei Francesi, Rome
1602	*Taking of Christ*	National Gallery of Ireland, Dublin
1602	*Deposition of Christ*	Vatican Pinacoteca, Rome
1603	*Doubting Thomas*	Stiftung Schlosser und Garten, Potsdam, Germany
1603	*Sacrifice of Isaac*	Uffizi, Florence
1603	*Madonna of Loreto*	Cavaletti Chapel, Sant'Agostino, Rome
1604	*Death of the Virgin*	Louvre, Paris
1605	*David and Goliath*	Prado, Madrid
1606	*St Jerome Writing*	Galleria Borghese, Rome
1606	*Palafrenieri Madonna*	Galleria Borghese, Rome
1606	*Seven Acts of Mercy*	Church of Pio Monte della Misericordia, Naples
1607	*Flagellation of Christ*	Capodimonte Palace, Naples
1608	*Beheading of John Baptist*	Oratory, St John's Cathedral, Valletta, Malta
1608	*Burial of St Lucy*	Palazzo Bellomo, Siracusa
1609	*Salome w/ head of John*	Palacio Real, Madrid
1609	(or 1605?) *Narcissus*	Palazzo Corsini, Rome
1609	*Raising of Lazarus*	Museo Regionale, Messina
1609	*Adoration of the Shepherds*	Museo Regionale, Messina
1609	(1608–10?) *Annunciation*	Musée des Beaux Arts, Nancy
1609	*Nativity with Saints*	San Lorenzo Oratory, Palermo (now missing)
1610	*Martyrdom of St Ursula*	Banca Commerciale Italiana, Rome
1610	*David with Head of Goliath*	Galleria Borghese, Rome

Notes

1 Lynn F. Orr. Classical Elements in the Paintings of Caravaggio. Unpublished Ph.D Dissertation, UCLA, 1982; Riccardo Bassani and Fiora Bellini. 'La Casa, Le "Robbe" Lo Studio del Caravaggio a Roma. Due documentii inediti del 1603 e del 1605', Prospettiva, 1993, 68–76; Sandro Corradini and Maurizio Marini. "The Earliest Acount of Caravaggio in Rome. Burlington Magazine, 1998, 25 ff; Catherine Puglisi. Caravaggio. London: Phaidon (1998), 18, Appendix VII, 420.

2 John Spike. Caravaggio. New York / London: Abbeville Press (2001), 22.

3 Puglisi, 20, states this is based on Mia Cinotti. Caravaggio: tutte le opere. Bergamo: Poligrafiche Bolis Bergamo (1983), 209 and Maurizio Calvesi. Le realtà del Caravaggio. Turin: Einaudi (1990), 117–118.

4 Puglisi, 28.

5 Helen Langdon. Caravaggio: A Life. New York: Farrar, Straus, Giroux (1998), 30.

6 Christopher Hibbert. Rome: Biography of a City. New York: Norton (1985), 175 ff.; M. Bussagli. Art and Architecture of Rome. Cologne: Könemann (1999), 564.

7 According to Paul Taylor at the Warburg Institute in London, it is well-known that so much artistic resurgence happened in Rome as a direct result of the 1527 Sack of Rome, but how can this be verified? Taylor statistically documented a huge upsurge of artists working in Rome between 1580–1640 using the Thieme-Becker / Vollmer Gesamtregister (Munich and Leipzig: K. G. Saur and E. A. Seemann, 1996–), more than doubling with an increase from around 200 artists in 1580 to around 500 artists in 1640.

8 Puglisi, 44, Spike 25.

9 John Varriano. "Caravaggio and Violence." Storia dell'Arte (1999), 321.

10 As quoted in Spike, 61 & 244: Cardinal Federico Borromeo. Musaeum: De Pictura Sacra, 1618, 32–33; published in 1625, edition of 1754, 132.

11 Timothy Wilson-Smith, Caravaggio. London: Phaidon (1998), 34; Spike, 43 ff.

12 Creighton E. Gilbert. Caravaggio and his Two Cardinals. University Park: Pennsylvania State University Press (1995), 118; Langdon, 97; Puglisi, 95; Spike notes, 54, that

Caravaggio knew and followed the iconography in Cesare Ripa's 1593 Iconologia handbook for painters where the imagery of music can also be shown by wine as an agent of intoxicating happiness.

13 Peter and Linda Murray. Oxford Dictionary of Christian Art, 95; Spike, 76.

14 David R. Cartlidge and J. Keith Elliott. Art and the Christian Apocrypha. New York: Routledge (2001), 99; Murray and Murray, 170.

15 Spike, 76–77.

16 J. Dillenberger. "The Magdalen: Reflections on the image of the saint and the sinner in Chrsitian Art" in D. Apostolos-Cappadona, ed. Image and Spirit in Sacred and Secular Art. New York: Crossword/Herder and Herder (1990), 28–50; Murray and Murray, 318, Spike 74.

17 I. Aghion, C. Barbillon and F. Lissarrague. Gods and Heroes of Classical Antiquity. Flammarion Iconographic Guides. Paris: Flammarion (1996), 136; Avigdor W. G Posèq. Caravaggio and the Antique. London: Avon Books (1998), 152–153.

18 Jean Weisz, pers. comm. at Doria Pamphilj Gallery, 2002.

19 Desmond Seward. Caravaggio: A Passionate Life. New York: William Morrow (1998), 47–48; Varriano, 318.

20 Varriano, 324.

21 Herwarth Röttgen. Il Caravaggio: Richerche e Interpretazione. Rome: Bulzoni (1974); but not so easy says Seward, 42–46; Puglisi, 62–65 &

201ff as well as Langdon, 6–7 and most modern historians.

22 Seward, 81–82.

23 Cartlidge and Elliott, 225.

24 Spike, 113.

25 Giorgio Bonsanti. Caravaggio. Florence: Scala (1991 rev. ed.), 63.

26 Peter Robb. M: The Man who Became Caravaggio. New York: Picador – Henry Holt (1998), 302–03.

27 Spike, 140.

28 Langdon, 137, 297.

29 Varriano, 320.

30 Seward, 98, citing Maurizio Calvesi.

31 Langdon, 324.

32 Posèq does not cite this Roman story in his study of Classical motif.

33 Wilson-Smith, 20.

34 Langdon, 353, noting again how nobility was so important to the order.

35 Spike, 212.

36 For an example of earlier John the Baptist traditions, see Richard Reed. Studies in the Patronage of Giorgio Vasari , 1511–1574. Unpublished D. Phil. Dissertation, Oxford University, 1999, 137.

37 Puglisi, 306.

38 Posèq, 15.

39 Puglisi, 259.

40 Robb, 474.

41 Cited in Seward, 167–68, Maurizio Marini. "Caravaggio: l'ultima spag-gia." Il Tempo, 1995.

42 Varriano, 317, 319–320.

43 Langdon, 365.

44 Varriano, 318, 321.

45 Puglisi, 252–53; Spike, 116, 121–123, 240.

Chronology

Year	History	Culture
1571	St Bartholomew's Day Massacre of French Huguenots, Paris	
1572-85	Pope Gregory XIII (Boncompagni)	

Year	History	Culture
		Barocci's *Visitation* in Santa Maria in Vallicella
1585-90	Pope Sixtus V (Peretti)	Laureti's frescoes of the founding of
1586	Vatican obelisk erected by Fontana	the Roman republic for the Sala dei
1587-89	Bronze Statues of SS. Peter and Paul placed on top of the columns of Trajan and Marcus Aurelius	Capitani in the Palazzo dei Conservatori. *Circumcision of Christ* by Girolamo Muziano (1532-92) for the
1592-1605	Pope Clement VIII	high altar of Il Gesù commissioned by Cardinal Alessandro Farnese Scipione Pulzone's *Lamentations* for Il
1593	Henry IV (of France) converts to Catholicism. Independent order of Carmelites established. Saint Francis de Sales is ordained	Gesù. Christopher Marlowe dies Shakespeare: *Richard III*, *The Comedy of Errors, Taming of the Shrew, Titus Andronicus* and the poem *Venus and Adonis* George La Tour, French painter influenced by Caravaggio is born
1594	Henry IV (of France) is crowned in Chartres	Remains of Pompei discovered Orlando di Lasso, Dutch composer, dies

1595 24 employed in Rome by Cardinal del Monte, first real appreciative patron, moves into his household in Palazzo Madama near San Luigi dei Francesi; paints *Musicians* and the *Lute Player,* dines often with Cardinal Del Monte in his house functions with the cardinal's sophisticated musical and literary circle (first *Lute Player* may be for Marchese Vincenzo Giustiniani, friend of Del Monte

1595 24 meets or begins association with *cortigiana* Anna Bianchini

1596 25 paints *Rest on Flight into Egypt* and *Penitent Magdalen* with Bianchini as model

1597 26 paints *Bacchus* and *Medusa* and his only known fresco, *Jupiter, Neptune and Pluto*; meets or begins association with friends such as Onorio Longhi and also the *cortigiana* Fillide Melandroni

1597 26 accosts a barber's apprentice, starts to becomes known for *bravi* behavior

1598 27 May 4, arrested and placed in Tor di Nona prison for sword-carrying and brawling

1598 27 sells a painting, *St John the Baptist*, to Ottavio Costa, who also commissions *Mary and Martha* (also known as *Conversion of Mary Magdalene*), and another *Lute Player* for Del Monte

1598 27 paints *Judith Beheading Holofernes* with Fillide Melandroni as model; in following year paints *St. Catherine of Alexandria*, also with Fillide as model

1599 28 July 23, first major public commission to paint *Life of Matthew* series for Contarelli Chapel of San Luigi dei Francesi, the French national church in Rome, aided by Cardinal Del Monte and his court and clerical influence

1600 29 September 24, commissioned to paint *Crucifixion of St Peter* and *Conversion of St. Paul* for Cerasi Chapel of Santa Maria del Popolo

1600 29 named as *EGREGIUS IN URBE PICTOR*, 'Distinguished City Painter of Rome' in Cerasi Chapel contract

1600 29 leaves household of Cardinal Del Monte [but not indirect patronage]

1601 30 paints *Supper at Emmaus* for Ciriaco Mattei, another Del Monte friend

1601 30 assaults Tommaso Salini, friend of artist Giovanni Baglione

Year	History	Culture
1595	Start of the Dutch colonies in East India. Walter Raleigh leads expedition up the Orinoco River	Torquato Tasso (Italian poet) dies. Clément Janequin (French composer) dies. University of Ljubljana founded
1596	Warsaw becomes Polish capital. Maurice of Nassau negotiates a triple alliance with France and England against Spain.	Brueghel returns to Antwerp from Italy
1597	Amiens captured by the Spanish	Carracci brothers start fresco decoration of the Gallery of the Farnese Palace in Rome
1598	Philip III becomes King of Spain and Portugal. Edict of Nantes issued by Henri IV of France granting toleration to Huguenots	Francisco Ribalta settles in Valencia and is influenced by Caravaggio
1599	Beatrice Cenci's Beheading in Rome. Globe Theatre built in London	
1600	Giordano Bruni's execution in Rome Jubilee: Unprecedented numbers of pilgrims attend celebrations in Rome. East India Company (English) founded. Henry IV of France marries Marie di Medici British East India Tea Company established	Peter Paul Ruben's arrival to Italy Shakespeare, *Henry IV, Henry V, Henry VI* El Greco, *Resurrection* Galileo, Law of Inertia
1601	Robert Essex is accused of a plot to overthrow Elizabeth I and executed	Shakespeare, *Hamlet, Julius Caesar* Rubens, *Passion* (3 altarpieces) Henry IV of France founds the tapestry manufacture Gobelin

1602 31 paints his *Death of the Virgin*, commissioned in 1601, but rejected by the
 Roman Carmelite church, Chiesa della Scala in Trastevere, and also paints
 his *Entombment of Christ* [or *Deposition*] as well as *Taking* [or *Betrayal*] *of
 Christ* among other paintings including his *Amor Vincit Omnia*

1603 32 by midyear, paints *Doubting Thomas* and *Sacrifice of Isaac,* latter for Maffeo
 Barberini

1603 32 September 11, famous libel trial brought against him by the artist and
 critic Giovanni Baglione [later one of his biographers], charged and
 imprisoned in Tor di Nona prison for two weeks, released September 25

1603 32 after release from prison, rents rooms from Madama Prudenzia Bruno

1603 32 his art noted as 'walking a tightrope between the sacred and the profane'
 by a Cardinal Paravicino in a letter to another clergyman

1603 32 paints *Madonna of Loreto* with *cortigiana* Lena Antonietti as possible model,
 probably in some relationship with her from 1604 onwards

1604 33 in April fined for throwing boiling *carciofi* [artichokes] at a waiter

1605 34 in July fights and wounds Mario Pasqualone, a notary, over jealousy about
 'his girl Lena' [Antonietti], flees Rome for Genoa and then returns to find
 landlady's court suit over nearly six months back rent in arrears

1605 34 by this time had at least five major paintings rejected by commissioners,
 including first *Matthew and Angel* (1601), first *Conversion of Paul* (1601)
 and likely first *Crucifixion of Peter*, possibly others, as well as *Death of the
 Virgin* already noted (1602), and possibly including the heavily criticized
 Madonna of Loreto (1603) and definitely including *Palafrenieri Madonna*
 (1605) rejected by St Peter's Basilica, although all were fairly soon
 snatched up by influential admirers

1605 34 finds patronage of Scipio Borghese, nephew to pope, paints the portrait of
 Camillo Borghese as *Pope Paul V,* and paints *David with Head of Goliath,*
 possibly also paints *Narcissus* [?]

1605 34 by this time he has been arrested or imprisoned in Rome at least 11 times
 for brawling, sword fighting, assault and other charges for violence and
 damages, including insults to police, attempted attacks on other artists or
 their workplaces, including challenging both Guido Reni and Giuseppe
 Cesari, now Cavaliere d'Arpino to duels and having to pay a fine of 500
 scudi for being wounded in a swordfight on October 24, 1605

1602 — Dutch East India Company – the first public company - founded
Dutch found a colony at the Cape of Good Hope, South Africa
Bodlean Library, Oxford established

Shakespeare, *Troilus and Cressida*
Foundations laid for the Bodleian Library in Oxford Parisian Charité founded

1603 — Elizabeth I dies, James VI King of Scotland accedes as James I of England and Ireland. Hieronymus Fabricius (of Aquapendente) gives the first clear description of the valves of the veins, in his *De venarum ostiolis* Göteborg is founded

Carlo Maderna begins the completion of St Peter in Rome
Johannes Bayer publishes *Uranometrie* and introduces the modern names of the stars and constellations El Greco, the complete altar composition for the Hospital de la Caridad at Illescas (1603–05), for which he also worked as architect and sculptor

1604 — Peace is signed between England and Spain

1605 — The Dutch seize Amboyna, Malaysia. Akbar, greatest of the Mogul emperors of India, dies. Santa Fé, New Mexico is founded. King Charles IX of Sweden goes to war with Poland. A small settlement is made in Nova Scotia (Arcadia). Boris Godunov, Tsar of Russia (1598–1605), dies in Moscow

Jonson, *Volpone* John Dowland, *Lachrymae, or Seaven Teares, in Seaven Passionate Pavans* Inigo Jones (British painter, architect, and designer) designs the scenes and costumes for masques by Jonson and others Sir Francis Bacon, *The Advancement of Learning*

1606 35 May 28, fatally wounds his bravi enemy Ranuccio Tomassoni in sword fight, flees Rome for Alban Hills and Lazio countryside, charged with murder, flight to Naples to family of Marchese of Caravaggio

1606 35 October through following March, paints several pictures in Naples, including *Seven Acts of Mercy, Flagellation of Christ* and *Portrait of a Knight of Malta*

1607 36 goes to Malta to begin novitiate with Knights of Malta for almost a year living under religious order with vows, unusual because he has no nobility

1608 37 February 7, papal dispensation granted for novitiate, accepted into Knights of Malta on July 14, having painted *Beheading of John the Baptist* (his only signed painting) for Knights of St. John Cathedral, Valletta, Malta

1608 37 assaults a senior Knight of Malta, imprisoned but around October 6, escapes formidable prison with help to Sicily, later formally 'defrocked' in *privatio habitus* (loss of habit) by Knights of Malta, declared fugitive and stripped of knighthood, which he refuses to accept

1608 37 in Siracusa lives with old friend Mario Minniti, paints *Burial of St. Lucy*, leaves for Messina where around December he begins painting *Adoration of Shepherds* and *Raising of Lazarus*; in mid 1609 after being charged by school teacher there for indecency, leaves for Palermo for a few months

1609 38 by autumn back in Naples to take refuge with family of Marchese of Caravaggio, paints *Annunciation* [?] and among other paintings, *Magdalen in Ecstasy, Martyrdom of St. Ursula* and possibly last painting, *David with Head of Goliath*

1610 39 attacked outside notorious wharf tavern in Naples' seafront

1610 39 in spring, promised papal pardon negotiated by Cardinal Gonzaga, leaves Naples by sea, arrested en route at sea, all his belongings confiscated including several paintings; impetuously attempts to cross malarial swamps, under great stress and probably in great anger as well as fear for his life

1610 39 mid-July, dies of fever at Porto Ercolano, probable anonymous burial there in small chapel garden of Confraternity of Santa Cruz

Year	History	Culture
1606	The Spanish navigator Torres sails between New Guinea and Australia The Portuguese discover Vanuatu London Company is chartered by James I to colonize the eastern American coast.	Shakespeare, *King Lear, Macbeth* Rembrandt (Harmenszoon) van Rijn is born Joseph Scaliger, *Thesaurus Temporum* (a chronology of the ancient world)
1607	Virginia the First English colony in North America is proclaimed	
1608	French found their first North American colony in Quebec. Jesuit state founded in Paraguay. A Protestant Union of German princes opposing the Catholic *bloc* is formed	Claudio Monteverdi performs his opera, *Orfeo* in Milan Shakespeare, *Coriolanus, Anthony and Cleopatra* El Greco, *Cardinal Taverna* the privilege for the telescope is granted to Hans Lipperhey (Dutch)
1609	The Amsterdam Exchange Bank is founded (and becomes Europe's largest clearinghouse) Tea from China is first shipped to Europe by the Dutch East India Company	While at the University of Padua, Galileo Galilee constructs the first complete astronomical telescope Shakespeare, *Sonnets* Rubens, *Self portrait with his wife Isabella Brant*
1610	Henry IV of France murdered; succeeded by Louis XIII	Kepler, *Astronomia nova* (Laws of Planetary Motion) Galileo discovers the moons of Jupiter, the phases of Venus, mountain ranges on the Moon, the rings of Saturn, and the Milky Way

Bibliography

PRIMARY SOURCES IN THE SEVENTEENTH AND EIGHTEENTH CENTURIES

Giovanni Battista Agucchi. *Trattato della pittura,* 1646 [under pseudonym of G. A. Mosini], acc. D. Mahon (1947).

Giovanni Baglione. *Le Vite de' pittori, scultori et architetti.* Rome (1649).

Giovan Petro Bellori. *Le Vite de pittori, scultori ed architetti moderni.* Rome, 1672, ed. Evelina Borea, Turin (1976).

Giulio Mancini. *Considerazione sulla pittura,* 1617–21. ed. Adriana

Marucchi and Luigi Salerno, 2 vols. Rome (1956–57).

Karl van Mander. *Het Schilder-boek.* Haarlem, 1604.

Joichim von Sandrart. *L'Academia tedesca dell' architettura, scultura et pittura 1675 (Academie der Blau, Bild und Mahlerey-Kunst von 1675.* A. Peltzer edition, Munich (1925).

F. Susinno. *Le vite de' pittore messinesi, 1724.* Florence: V. Martinelli ed. (1966).

MODERN SECONDARY SOURCES

F. Ashford. 'Caravaggio's Stay in Malta'. *Burlington Magazine* (1935) June.

P. Askew. 'Caravaggio: Outward Action, Inward Vision' in S. Macioce, ed. *Michelangelo Merisi da Caravaggio: La Vita e l'eOpere attraverso i Documenti.* Rome (1995).

Riccardo Bassani and Fiora Bellini. 'La Casa, Le "Robbe", Lo Studio del Caravaggio a Roma. Due documenti inediti del 1603 e del 1605', *Prospettiva* vol. 71 (1993), 68–76.

S. Benedetti. *Caravaggio: The Master Revealed.* Dublin (1995).

Per Bjurström. *Drawings from the Age of the Carracci:* Seventeenth Century Bolognese Drawings, Nationalmuseum, Stockholm. Oxford: Ashmolean Museum, (2002).

Giorgio Bonsanti. *Caravaggio.* Florence, Scala (1991 rev. ed.).

Julian Brooks. *Graceful and True: Drawing in Florence c. 1600.* Oxford: Ashmolean Museum (2003).

Christopher Brown. 'The Caravaggesque Painters' in *Utrecht Painters of the Dutch Golden Age.* London: National Gallery (1997).

Marco Bussagli, ed. 'Seventeenth Century Painting and Caravaggio's Challenge' in *Rome: Art and Architecture*. Cologne: Könemann (1999), esp. 550–562.

Maurizio Calvesi. *La realtà del Caravaggio*. Turin (1990).

F. T. Camiz. 'Music and Painting in Cardinal Del Monte's Household'. *Metropolitan Museum Journal*, 23 (1991).

David R. Cartlidge and J. Keith Elliott. *Art and the Christian Apocrypha*. New York: Routledge (2001).

Keith Christiansen. 'The Genius of Rome'. *Burlington Magazine* (2001) June. London, 383–86.

Mia Cinotti, *Caravaggio: tutte le opere*. Bergamo (1983).

Mia Cinotti, 'Vita del Caravaggio', in *Caravaggio: Nuove riflessioni*, Quaderni di Palazzo Venezia 6. Rome (1989).

Sandro Corradini. *Caravaggio: Materiali per un processo*. Rome (1993).

Sandro Corradini and Maurizio Marini. 'The Earliest Account of Caravaggio in Rome'. *Burlington Magazine*, vol. 140 (1998) 25 & ff.

Giuseppe de Logu (tr. John Shepley). *Caravaggio*. New York: Harry Abrams, *n.d.*

K. H. Fiore, ed. *Guide to the Borghese Gallery*. Rome: Edizione de Luca (1997).

W. Friedlaender. *Caravaggio Studies*. Princeton (1955).

John Gash. *Caravaggio*. London: Jupiter Books (1980).

Creighton E. Gilbert. *Caravaggio and his Two Cardinals*. University Park: Pennsylvania State University Press (1995).

Christopher Hibbert. *Rome: Biography of a City*. New York: Norton (1989).

Ian Jenkins and Kim Sloan. *Vases and Volcanoes: Sir William Hamilton and His Collection*. London: British Museum (1996).

Helen Langdon. *Caravaggio: A Life*. New York: Farrar, Straus, Giroux (1998).

Roberto Longhi. *Caravaggio*. Edition Leipzig. Verlag V.E.B. Dresden (1968).

Edward Lucie-Smith. *Sexuality in Western Art*. World of Art. London: Thames and Hudson (rev. ed. 1991, repr. 1997).

M. Marini. *Caravaggio. Michelangelo Merisi da Caravaggio 'pictor praestantis-simus'*, 2nd rev. ed., Rome (1989).

Alfred Moir. *Caravaggio*. New York (1982).

Gioia Mori. 'Projects of the end of the century' in Bussagli (1999), 484–93.

F. Mormando, ed. *Saints and Sinners: Caravaggio and the Baroque Image*. McMullen Museum of Art, Boston College (1999).

Peter and Linda Murray. 'Caravaggio' in *Oxford Dictionary of Christian Art*. Oxford (1996).

Daniele Ohnheiser. *A Journey to Naples and Pompeii*. Rome: Palombo Editore (2002).

Lynn F. Orr. 'Classical Elements in the Paintings of Caravaggio.' Ph.D Dissertation, UCLA (1982).

V. Pacelli. 'New Documents Concerning Caravaggio in Naples'. *Burlington Magazine* (1977) December.

Avigdor W. G. Posèq. *Caravaggio and the Antique*. London: Avon Books (1998), esp. 28–29.

Catherine Puglisi. *Caravaggio*. London: Phaidon (1998).

Richard Reed. *Studies in the Patronage of Giorgio Vasari, 1511–1574*. Unpublished D. Phil. Dissertation, Oxford University (1999).

Peter Robb. *M: The Man Who Became Caravaggio*. New York: Picador-Henry Holt (1998).

Patricia Lee Rubin. *Giorgio Vasari: Art and History*. New Haven: Yale University Press (1995).

Desmond Seward. *Caravaggio: A Passionate Life*. New York: William Morrow (1998).

G. Spagnesi, M. Caperna, A. Cesarei,

C. Corradini, P. Dell'Acqua, P. Spagnesi. *La Pianta di Roma al Tiempo di Sisto V (1585–1590)*. Roma: Multigrafica Editrice (1992).

John R. Spencer, tr. *Leon Battista Alberti: On Painting*. New Haven: Yale University Press (1966).

John Spike. *Caravaggio*. New York / London: Abbeville Press (2001).

Nicola Spinosa, ed. *The National Museum of Capodimonte*, Naples: Electa Napoli (1996).

Paul Taylor. *Notes on Statistical Correlations of Painters from Thieme-Becker*. London, Unpublished (2003).

I. Toesca. 'Observations on Caravaggio's "Repentant Magdalen".' *" Journal of the Warburg and Courtauld Institutes*. Vol 24. London (1961) 114–115.

John Varriano. 'Caravaggio and Violence' *Storia dell'Arte* 97, Florence (1999), 317–32.

Zbigniew Wabiski. *Il Cardinale Francesco Maria Del Monte 1549–1626*, Florence (1994), esp. 377 ff.

Timothy Wilson-Smith. *Caravaggio*. London: Phaidon (1998).

Picture Sources

The author and publishers wish to express their thanks to the following sources of illustrative material and/or permission to reproduce it. They will make proper acknowledgements in future editions in the event that any omissions have occurred.

Bridgeman Art Library: pp. 19, 21, 23, 25, 35, 36, 39, 41, 45, 58, 70, 72, 75, 77, 78, 82, 86, 89, 91, 116, 133. Corbis: pp. ii, 31. Scala Art Resource: pp. 56, 81, 121, 124, 126,130.

PLACE	ARCHITECT	POPE	DATE
Sancta Sanctorum	Domenico Fontana	Sixtus V	1585–90
Lateran Palace	Domenico Fontana	Sixtus V	1585–90
Basilica of St. John Laterani	Domenico Fontana	Sixtus V	1585–90
Ch. Santa Pudenziana	Alessandro Volterra	Cardinal Caetani	1589
Ch. SS Quattro Coronati		Pius IV	1559–65
Papal Palace		Sixtus V	1585–90
Villa Mattei-Caelimontana			1582 onward
Palazzo Mattei di Giove			1598
Palazzo del Senatore Giacomo della Porta			
	Giralamo Rainaldi		1582 onward
Piazza del Campidoglio Clocktower			
	Martino Longhi		c. 1580
Basilica of SS Apostoli		Pius IV	1559–65
Ch. San Lorenzo in Panisperna			1575
Vatican Library (Salone Sistina)		Sixtus V	1585–90
Ch SS Nereo e Achilleo			1597
Collegio Romano Gregorian University			
	Bartolommeo Ammanati		1583–85
Riario Palazzo	Martino Longhi		1580
Palazzo Farnese	Giacomo della Porta		1574
Palazzo dei Conservatori Giacomo della Porta			1568
Villa Giulia (Villa di Papa Giulio)			
	Vignola	Julius III	1551 on
Palazzo Spada Giulio Merisi da Caravaggio			1549 on
Ch. San Ignazio			1551 on
Ch. Gesù	Vignola-Valeriani	[A. Farnese]	1568–84
Ch. Santa Maria in Vallichella Philip Neri,		Martino Longhi	1580 on
Accademia di San Luca			1588
Belvedere Bibliotheca	Domenico Fontana	Sixtus V	1585–90
Court of Saint Damasus	Clement VII-Sixtus V		after 1530–1588
Sistine Loggia	Domenico Fontana	Sixtus V	1586
Capella Gregoriana			1583
Capella Sistina in Maria Maggiore			
	Domenico Fontana	Sixtus V	1585

PLACE	ARCHITECT	POPE	DATE
Capella Clementina	Giacomo della Porta		1570 on
Capella Paolina-Borghese Chapel			begun before 1600
Galleria della Carta Geographiche			
	Martino Longhi	Gregory XIII	c. 1580
Santa Cecilia		Clement VIII	c. 1595
Santa Susanna		Clement VIII	c. 1595

Index

LIFE & TIMES FROM HAUS

Churchill
by S. Haffner
'One of the most brilliant things of any length ever written about Churchill.' *TLS*
1-904341-07-1 (pb)
1-904341-06-3 (hb)
£8.99 (pb) £12.99 (hb)

Curie
by S. Dry
'...this book could hardly be bettered' *New Scientist*
selected as Outstanding Academic Title by *Choice*
1-904341-29-2
£8.99 (pb)

Dietrich
by M. Skaerved
'It is probably the best book ever on Marlene.' C. Downes
1-904341-13-6 (pb)
1-904341-12-8 (hb)
£8.99 (pb) £12.99 (hb)

Einstein
by P.D. Smith
'Concise, complete, well-produced and lively throughout, ... a bargain at the price.' *New Scientist*
1-904341-15-2 (pb)
1-904341-14-4 (hb)
£8.99 (pb) £12.99 (hb)

Beethoven
by M. Geck
'...this little gem is a truly handy reference.' *Musical Opinion*
1-904341-00-4 (pb)
1-904341-03-9 (hb)
£8.99 (pb) £12.99 (hb)

Casement
by A. Mitchell
'hot topic' *The Irish Times*
1-904341-41-1
£8.99 (pb)

Prokofiev
by T. Schipperges
'beautifully made, . . . well-produced photographs, . . . with useful historical nuggets.' *The Guardian*
1-904341-32-2 (pb)
1-904341-34-9 (hb)
£8.99 (pb) £12.99 (hb)

Britten
by D. Matthews
'I have read them all - but none with as much enjoyment as this.' *Literary Review*
1-904341-21-7 (pb)
1-904341-39-X (hb)
£8.99 (pb) £12.99 (hb)

De Gaulle

by J. Jackson
'this concise and distinguished book' Andrew
Roberts *Sunday
Telegraph*
1-904341-44-6
£8.99 (pb)

Dostoevsky

by R. Freeborn
'... wonderful ... a
learned guide' *The
Sunday Times*
1-904341-27-6 (pb)
£8.99 (pb)

Orwell

by S. Lucas
'short but controversial
assessment ... is sure to
raise a few eyebrows'
Sunday Tasmanian
1-904341-33-0
£8.99 (pb)

Brahms

by H. Neunzig
'readable, comprehensive and attractively
priced'
The Irish Times
1-904341-17-9 (pb)
£8.99 (pb)

Bach

by M. Geck
'The production values
of the book are exquisite, too.'
The Guardian
1-904341-16-0 (pb)
1-904341-35-7 (hb)
£8.99 (pb) £12.99 (hb)

Verdi

by B. Meier
'These handy volumes
fill a gap in the market
... admirably.'
Classic fM
1-904341-21-7 (pb)
1-904341-39-X (hb)
£8.99 (pb) £12.99 (hb)

Kafka

by K. Wagenbach
'One of the most useful
books about Kafka ever
published' *Frankfurter
Allgemeine Zeitung*
1-904341-02-0 (pb)
1-904341-01-2 (hb)
£8.99 (pb) £12.99 (hb)

Armstrong

by D. Bradbury
'generously illustrated
... a fine and well-
researched introduction' George Melly
Daily Mail
1-904341-46-2 (pb)
1-904341-47-0 (hb)
£8.99 (pb) £12.99 (hb)